TRACING Y
SEAFARING
ANCESTORS

FAMILY HISTORY FROM PEN & SWORD

TRACING YOUR SEAFARING ANCESTORS

A Guide to Maritime Photographs for Family Historians

Simon Wills

Pen & Sword
FAMILY HISTORY

First published in Great Britain in 2016
PEN & SWORD FAMILY HISTORY
an imprint of
Pen & Sword Books Ltd
47 Church Street, Barnsley
South Yorkshire, S70 2AS

ISBN 978 1 47382 857 5

A CIP catalogue record for this book is
available from the British Library.

Typeset in Palatino and Optima by CHIC GRAPHICS

Printed and bound in England by
CPI Group (UK), Croydon, CR0 4YY

Pen & Sword Books Ltd incorporates the imprints of Pen & Sword
Archaeology, Atlas, Aviation, Battleground, Discovery, Family History,
History, Maritime, Military, Naval, Politics, Railways, Select, Social History,
Transport, True Crime, Claymore Press, Frontline Books, Leo Cooper,
Praetorian Press, Remember When, Seaforth Publishing and Wharncliffe.

For a complete list of Pen & Sword titles please contact
PEN & SWORD BOOKS LTD
47 Church Street, Barnsley, South Yorkshire, S70 2AS, England
E-mail: enquiries@pen-and-sword.co.uk
Website: www.pen-and-sword.co.uk

* * *

On the front cover:
Royal Navy first class petty officer in tropical uniform, c.1890 (top left).
Royal Navy Commander Stanley Miller on HMS *Thunderer*, 1912 (top right).
Fisherman at Southwold, 1880s (bottom left).
Merchant navy surgeon with the African Steamship Company, c.1900 (bottom right).

CONTENTS

To my brother, Richard

PREFACE

This book examines how British seafarers were captured on camera during the period 1850 to 1950, and offers information and advice on how to interpret their roles, ranks and experiences.

Achieving this in one book is a difficult task and, understandably, it is not possible to illustrate and describe every single type of uniform or clothing worn by our maritime ancestors. In many instances this book will help you discover what a person in an old photograph did for a living. However, sometimes you will need to undertake further research yourself to understand a photograph more completely. In these situations I hope that I have included sufficient images and information to have at least pointed you in the right direction.

I have suggested a few archive resources that may help you begin to investigate an ancestor's career too, but these are only examples to help start you off. Please consult more specialist sources for each seafaring profession for more comprehensive advice.

Terminology

The men who worked on a ship in the Royal Navy or merchant service have been referred to variously throughout history as seamen, sailors or mariners. The Navy has also used the term 'rating' to refer to its non-officers. Yet, for consistency I have generally used the word 'seaman' throughout this book to describe professional men who worked on a ship. Similarly, I have used the term 'merchant navy' to refer to the crews of commercial cargo and passenger ships, even when discussing eras when this was not an established term.

There is some difference of opinion on the correct terms to use to describe certain aspects of clothing and insignia of rank. I apologise if I have not used terms that individual readers have a preference for, but for clarity and consistency I have adopted the following:

- 'Cuff stripes' to refer to the sleeve markings or distinction lace used to denote the rank of officers.
- 'Shoulder straps' to describe the flaps of material running across the tops of shoulders which may carry information about rank.
- 'Branch badges' for the various embroidered insignia worn on the right upper sleeve by naval ratings to indicate their specialist line of work. These are sometimes called non-substantive or 'trade' badges.

ACKNOWLEDGEMENTS

I am indebted to the following experts who kindly gave me their time, access to resources and ideas:

Heather Johnson, librarian and archivist, Royal Naval Museum Library, Portsmouth.

Ian Maine, Deputy Head of Collections & Subject Specialist Royal Marines, Royal Marines Museum, Portsmouth.

Vicky Green, cruise-ship specialist, Maritime Collection, Southampton Central Library.

Chris White, secretary, Royal Fleet Auxiliary Historical Society.

Elise Chainey, collections officer, RNLI Heritage.

LIST OF ABBREVIATIONS

ADM	Admiralty (series of records at TNA)
BT	Board of Trade (series of records at TNA)
ERA	Engine Room Artificer
FAA	Fleet Air Arm
HMS	His/Her Majesty's Ship
P&O	Peninsular and Oriental Steam Navigation Company
QARNNS	Queen Alexandra Royal Naval Nursing Service
RAF	Royal Air Force
RFA	Royal Fleet Auxiliary
RFR	Royal Fleet Reserve
RMS	Royal Mail Ship
RN	Royal Navy
RNAS	Royal Naval Air Service
RNASBR	Royal Naval Auxiliary Sick Berth Reserve
RNAV	Royal Naval Artillery Volunteers
RND	Royal Naval Division
RNMBR	Royal Naval Motor Boat Reserve
RNR	Royal Naval Reserve
RNRT	Royal Naval Reserve, Trawler section
RMA	Royal Marines Artillery
RMLI	Royal Marines Light Infantry
RNLI	Royal National Lifeboat Institution
RNTS	Royal Naval Transport Service
RNVR	Royal Naval Volunteer Reserve
SS	Steamship
SV	Sailing Vessel
SY	Sailing Yacht
TNA	The National Archives (at Kew, London)
WRNS	Women's Royal Naval Service

Chapter 1

SEAFARERS ON CAMERA

Maritime undertakings are a dominant feature of British heritage. From the earliest times, residents of the British Isles have sought to cross the seas, navigate the coast, protect the shores and people, and make a living by fishing.

Yet, once Britain began to build an empire, a powerful Royal Navy was required to defend it and to fight wars, and similarly a large merchant fleet was needed to transport the goods and personnel that were the lifeblood of the Empire's trade.

Statistics from the past bear witness to the frequency with which modern family historians uncover ancestors with a connection to the sea. At the time of the Battle of Trafalgar there were over 130,000 men in the navy – a culmination of a hundred years of growth and expansion. Yet by 1820, following the defeat of Napoleon, Royal Navy personnel had slumped to less than 20,000 because there was peace – a peace that continued without major interruption right up until the First World War. However, once there was peace in Europe, trade could escalate and it was then the turn of the merchant fleet to expand rapidly. By the 1840s around 40 per cent of all merchant ships worldwide were registered in the British Empire, with four new ships being built to join the fleet *every day* in some years.

With all this shipping, British waterways were not necessarily very safe. Figures from the 1860s, for example, show that about ten commercial ships per week were lost on the coast of Britain alone. As a result, whole professions emerged with roles centred on safety at sea, such as coastguards, lifeboatmen and pilots.

At the end of the nineteenth century, the overwhelming dominance of the British in world merchant shipping can be seen by examining the numbers of vessels registered in each nation. In 1899 there were 10,998 British-registered steam or sailing ships over

100 tons. Even discounting the two-thousand or so of these that operated from ports outside the British Isles, Britain's merchant fleet dwarfed its closest mercantile rival the USA, which had only 2,739 seagoing ships.

In the twentieth century, there were two world wars where shipping played important offensive, defensive, economic and strategic roles. Ships were sunk in great numbers with the loss of many lives, but new vessels were built very quickly to replace them and new crews recruited. In peacetime, the twentieth century also saw the heyday of the passenger liner at a time before long-distance commercial flights were possible.

All of these nautical requirements – military, commercial, safety related – needed people to fulfil them. Hence the dominance of sea-related professions in British history, and the frequent occurrence of photographs of maritime ancestors.

Most maritime personnel throughout British history have been men. Women were introduced to seagoing roles via relatively humble positions – laundresses and stewardesses on oceangoing ships in the nineteenth century, for example. In the twentieth century, women were eventually recruited to the navy with the establishment of the Women's Royal Naval Service but progress has been slow, and even in the twenty-first century maritime careers are dominated by men.

Analysing Maritime Photographs

When assessing photographs of maritime ancestors, it is helpful to ask the following questions:

1. WHO might the person or persons be?
2. WHEN was the photo taken?
3. WHERE was the photo taken?
4. WHAT was the role of the person or persons?
5. WHY was the photo taken?

1. Who Might the Person or Persons Be?

You may have a complete name to accompany a photograph and this

can obviously help with accurate interpretation of a maritime picture. But partial names written on the back of photos are also common, such as 'Captain Harper' or 'Uncle Algie', and these may still be useful. I recently was asked to identify the uniform of a seafaring man known to be from the Watson family who died in the First World War. 'Watson' is a very common surname and there were many possible contenders. Yet, once I recognised that the uniform in the photo was that of the British India Steam Navigation Company it was possible to name him. This company's war memorial lists only one Watson who died in the First World War, and his name was Robert.

Sometimes looking for knowledge gaps in your family tree may help you speculate about a name. I was shown a photograph of a young woman which had written on the back: 'Died at sea, 1898'. The owner had no idea who the sitter was, but there were three people in her family tree whose deaths she had not been able to find details of and who could have died in 1898. Following up each of them in turn revealed that one of these possibilities – Elizabeth Bowles – was a stewardess on board the SS *Mohegan* which sank in 1898.

Official records related to seafarers sometimes contain physical descriptions of men, and comparing a photograph with such a description may help to prove an individual's identity, particularly if he had distinguishing characteristics such as a scar. In the past, seamen were more likely than most to have tattoos and these may be visible in photographs. For example, the petty officer in Royal Navy 'whites' on the cover of this book has very obvious tattoos on his forearms. This man's identity was uncertain, but when the photograph was compared to the description of the most likely candidate, via service records, his tattoos helped verify his identity.

However, just because your collection of family photos includes a seafarer, do not assume that he was necessarily an ancestor. He could be someone's old school friend, a sweetheart or even a relative's crewmate.

2. When was the Photo Taken?

A precise date on the back of a photo is very helpful if it is correct, but beware those scribbled notes that say something like 'Grandad 1920s'. These dates guessed at some point in the future may be inaccurate.

There are various general clues to help you date an image: specialist books and websites can advise you on aspects such as dating by the type and style of photograph, and the use of clothing fashions to identify an era. If you have a photographer's name and address this can be one of the most useful methods of dating because local trade directories and censuses can tell you approximately when a photographer arrived at an address and when he was no longer resident. Often typing the business details into an Internet search engine will give you a head start because local historians sometimes research the photographers that have operated in their vicinity and publish their findings online.

However, there can be some specific indications of date in photos of maritime ancestors. The name of a ship on a seaman's cap or painted on a lifebelt in the background can be used to find out the years in which the vessel operated. Some ships existed for remarkably short lengths of time, so providing bookend dates for the image in question. Uniforms changed in style too and throughout this book I have drawn attention to examples of this. Officers of the Royal Naval Reserve (RNR), for example, stopped displaying 'RNR' on their caps from 1921 onwards: a helpful dating clue. Campaign medals can also be useful in this respect since they were awarded after a specific date: a photo of a Royal Marine wearing the Messina Earthquake Medal must have been taken after this tragic event in 1908, and in fact the medal was not awarded to most people until 1912. Finally, employers such as shipping lines may change their identities or even cease to exist beyond a particular year and this can also help pinpoint a date more precisely.

3. Where was the Photo Taken?

An intriguing aspect of the maritime photographs in many families'

collections is that they were taken at a variety of locations – sometimes from ports all over the world. Indeed, one of the commonest reasons for a photo to exist was simply that a man was separated from his family for a prolonged period, and he would send them a photograph just to show that he was all right. From the 1860s onwards, most ports around the world had photographic studios, and in the twentieth century many large liners had their own photographic studios on board as well.

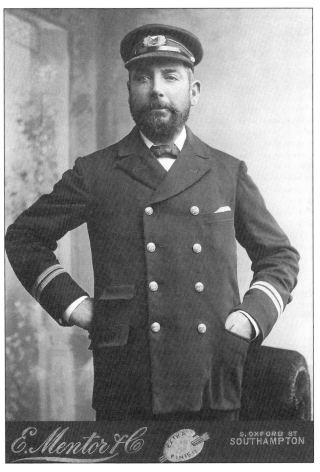

1. A photographer's location can help identify a seafarer's employer.

The twentieth century also saw the introduction of the photographic postcard allowing the person who'd been captured on camera to scribble a message on the back then simply add a stamp. This provided a quick, personal and very popular means to keep in touch. Furthermore, the twentieth century witnessed the rapid growth of photography as a hobby using portable cameras so that more and more images were created by amateurs and away from the professional studio. Accordingly, most photos actually taken on a ship at sea are from this century.

Sometimes the location where a photograph was taken can indicate a port where a seagoing individual lived or regularly worked. For example, a vital part of the analysis of the photograph in Figure 1 was that the image was taken in Southampton. The sitter's cap badge had proved difficult to identify: it showed a flag divided into four equal triangular quarters of different shades. Yet the Southampton connection prompted a hunt for local shipping lines, and this quickly turned up the Southampton, Isle of Wight and South of England Royal Mail Steam Packet Company Limited which operated from this port, and which used the characteristic four-coloured flag captured on the cap badge.

However, as noted above, the photographer's location may not always prove helpful because many maritime professions travelled widely. Nonetheless, the photograph's geographical origins are worth taking into consideration when trying to analyse an ancestor's photograph especially for men who pursued coast-bound roles such as inshore fishermen, pilots, coastguards, lifeboatmen or local ferry crews. In this chapter, Figures 1, 2, 5 and 8, for example, were all taken in locations where the sitter lived.

Some locations were particular popular. Many Royal Navy photos were taken in the neighbourhood of the principal military ports. Personnel based in Plymouth, for example, often had photos taken in the districts of that city known as Stonehouse or Devonport, and huge numbers of naval photos were also taken in Portsmouth or nearby Gosport. There was a large British naval base in Malta where Royal Navy personnel were often immortalised by the camera. Many merchant navy photos were taken in the big commercial ports of London, Liverpool or Southampton.

Study the background to a photo carefully. Was it taken on board ship? Be aware that photographers could use painted backdrops to give the impression that a photo had been taken at sea (see Figure 102). If a photo does genuinely capture a scene on a ship, what kind of vessel is it – a sailing ship or steamship, small or large, commercial or military? Is there anything in the photo that might help to identify the ship? Examples of the latter are discussed in the text in connection with Figures 43, 127 and 128.

4. What was the Role of the Person or Persons?

This book is concerned principally with helping you to answer this question. Specific clues to an ancestor's occupation can be provided by a variety of features, but the most important of these are:

- The presence of a uniform or not, and if so its overall appearance.
- Any lettering, names or motifs on the chest of jerseys; the design and arrangement of buttons.
- The style of headwear; characteristic badges on the front of caps indicating an employer; the names of ships or affiliations on caps; gold bands on caps or gold leaves on the peaks of caps.
- Insignia of rank, seniority and specialism such as stripes on sleeves or shoulders. Similarly, look for chevrons, anchors, crowns, lettering and pictorial badges on arms, collars and shoulders.
- Signs of war service such as wound badges, incomplete or hybrid uniforms, war chevrons.
- Medals can indicate length of service, participation in a military campaign or a state event, or an act of heroism.
- The arrangement of a group photo – senior persons are often in the middle at the front, and are also more likely to be the people sitting down.
- What are the subjects in the photo doing and where are they?

Medals can be very helpful in tracing careers, and a large number have been available to seagoing personnel. They have distinctive coloured ribbons, usually with lines of lighter and darker colours so

that even in black and white photographs it is often possible to identify them. The annually published *Medal Yearbook* (by Jon and Philip Mussell, Token Publishing Ltd) is an invaluable guide to identifying them since every medal is illustrated.

5. Why was the Photo Taken?

Seafarers did not always have a photograph taken to mark a significant career event. However, in practice maritime professionals often sought to have their photographs taken for a variety of specific reasons related to their employment. Men were keen to record their enlistment in the Royal Navy, their completion of training in the Royal Marines ('passing out'), their acceptance as an apprentice in the merchant navy and so forth. Similarly, significant promotions were occasions to celebrate and were moments commonly honoured

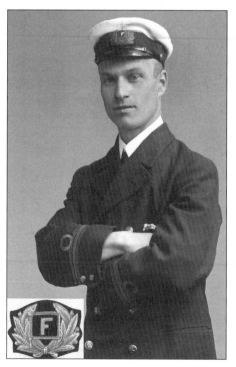

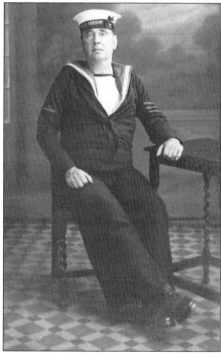

2. *Jack Holt Lucas marked a career milestone with a photo in 1912.*

3. *A photo to immortalise being called up – Ernest Barfoot, 1939.*

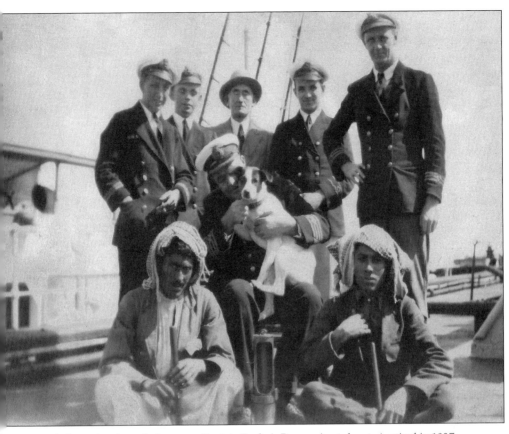

4. Capturing the end of a career: Captain Frederic Browne (seated centre) retired in 1937.

with a photograph. Figure 2, for example, shows Jack Holt Lucas in his first position after passing his exams to become a master mariner in the merchant navy with the Furness Line in 1912. Note the company's emblem of a large capital 'F' on his cap badge, and with a lens this letter can also be seen on his buttons.

Sometimes those earning a new role can be seen clutching their qualifying paperwork: an apprentice with his indentures, the naval lieutenant with his new commission (see Figure 57), the junior merchant navy officer with his mate's certificate and so forth.

Ernest Barfoot left the Royal Navy in 1927 and joined the service's veterans' organisation, the Royal Fleet Reserve. Yet, when war broke out in 1939 he hastened to re-join the Royal Navy and proudly had a photograph taken as soon as he had re-enlisted. This image can be seen in Figure 3. Ernest had the distinction of serving for the

whole duration of both world wars and survived them both. He was 52 years of age when he eventually retired from the sea in 1945. Many much younger men excitedly captured their first day in a new role, and it is one of the commonest reasons for a photo to be taken. Figure 26, for example, shows a selection of apprentice officers at the beginnings of their careers with the merchant service; similarly, young men joining the Royal Navy who were much younger than Ernest Barfoot also commonly sought to be immortalised by the camera (see Figures 59, 60 and 102).

At the other end of the career spectrum it is quite common, particularly in the twentieth century, for a seafarer to have a last photograph taken on board ship with crewmates before retirement, as Captain Frederic Browne did in 1937 (Figure 4). This photo was taken on board the SS *Ebonol* and Captain Browne is sat centrally with his dog. Similar commemorative photos are often found for other seafaring professionals, although it does seem to be more common for merchant navy officers. Figure 29, for example, is a merchant navy officer's 'demob' photograph, marking the end of his wartime duties.

A photograph might also be taken to commemorate an individual earning a particular award or distinction during their career. Figure 5 is a photograph of Abraham Hart Youngs from Brighton. He was a coastguard and was honoured on four occasions with medals from the Royal Humane Society and Royal National Lifeboat Institution (RNLI), which he can be seen wearing. This photograph was taken in 1881 to mark his award of a testimonial from the Royal Humane Society for a career in which he was credited with helping to save 170 people from drowning. The testimonial took the form of a large certificate which can be seen on an easel to the left of the photograph. Remarkably, the last of Abraham's rescues was only two years prior to the taking of this photograph when, aged 79, he dived fully clothed from an open boat to save a drowning man. The lifeboatman in Figure 110 is holding a rolled sheet, and this might also be a bravery testimonial.

In the Royal Navy it was common in the twentieth century to have photographs taken to signify achievement – particularly when

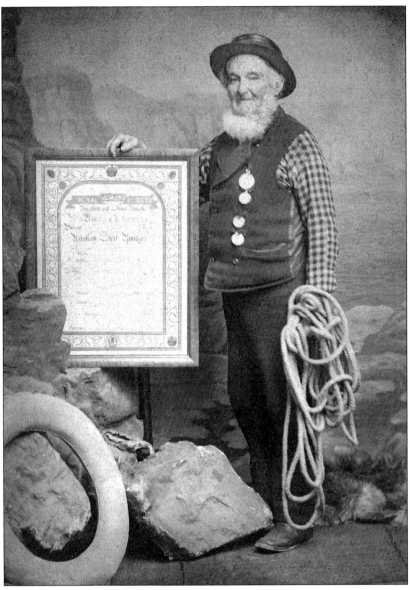

5. An image of heroism – Abraham Hart Youngs' latest bravery award, 1881.

a group of men accomplished something together. Figure 6 shows two of these. The uppermost picture was taken in 1947 – these young seamen have just completed their initial training before going to sea for the first time. In photos of this kind, you will often find a blackboard somewhere in the picture with the course date and name

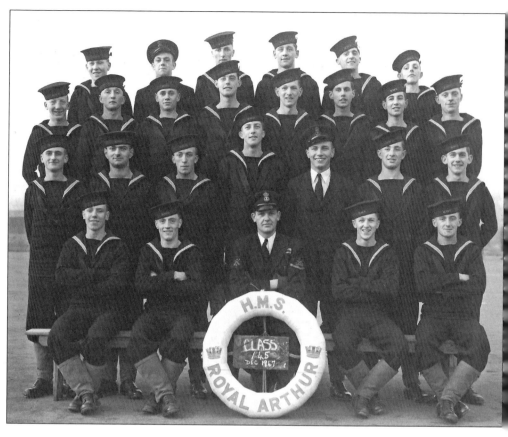

6. The Royal Navy often caught group events on camera in the twentieth century – training a batch of new recruits, 1947 (top) and an engineers' football team, 1917 (bottom).

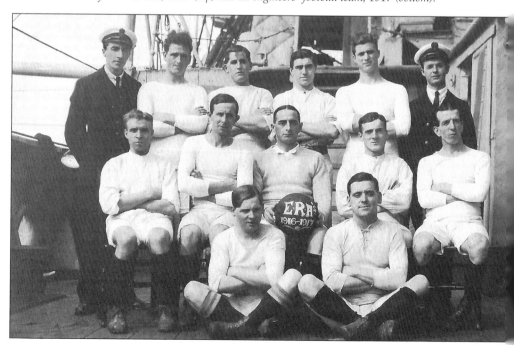

chalked upon it. In this case a lifebelt makes an appearance bearing the name HMS *Royal Arthur*. Yet *Royal Arthur* was not a ship: it was one of many naval shore establishments used for training that were given an 'HMS' designation – something to be aware of when analysing Royal Navy photographs. Many other naval training events were commemorated with photos of this kind in the twentieth century. Often men of the same rank were trained together.

Sporting competitions were another common reason for a group photo. Crewmen in the navy, particularly, might arrange football matches or other sporting events to compete against other ships, other ranks or against a local team when their vessel was in port, and there were often prizes for the winner. Ships might also stage theatrical events or musical concerts, and these were all opportunities for group photos, as was the occasion of a visiting dignitary. The lower picture in Figure 6 features a football team assembled on board a battleship comprising Engine Room Artificers (ERAs) in the Royal Navy in 1916–17 – their rank and the date being painted onto the football itself.

In the merchant navy, group photographs often commemorate a significant journey such as the maiden voyage of a ship, or perhaps its last. Photographs of senior officers taken prior to the departure of a ship on its maiden voyage often include their wives and children too. Some of the crew of SS *Demosthenes* are pictured in Figure 7 in early 1911, having turned out in their best uniforms to honour the ship completing its maiden voyage to Australia for the Aberdeen Line. Interestingly, shortly after the ship returned to England one of the young men on board left *Demosthenes* and eagerly hurried aboard his new and highly prestigious ship at Southampton, the RMS *Titanic*, which was also just about to take its maiden voyage. Ship's electrician, Alfred Middleton, is possibly pictured third from the right, immediately below a small dark rectangular door vent. Sadly, he was not to survive the great liner's encounter with the iceberg.

On a happier note, it is very common to find men from the merchant navy, Royal Navy, coastguards and Royal Marines in uniform at their own weddings. Both the Royal Navy and the Royal Marines had a range of uniforms that were selected for different

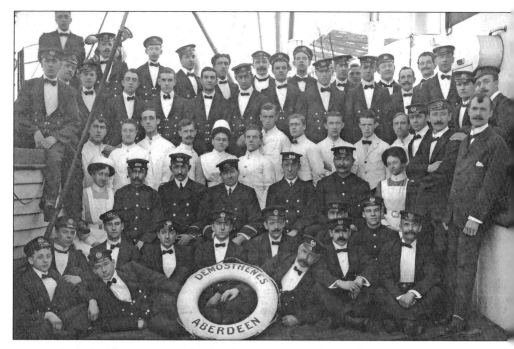

7. A significant moment for the ship's crew: completing the maiden voyage of SS Demosthenes, *1911.*

occasions depending on the formality of the proceedings. Figure 8 shows a lieutenant of the RNR on his wedding day in the 'frock coat' uniform used for formal occasions, complete with his sword and gloves. His RNR status is shown by the intertwined gold braid stripes on his cuffs – the two stripes with a star-shaped curl in the uppermost one indicating the rank of lieutenant (see Chapter 5). Similarly, the buttonhole rose worn in Figure 19 suggests that this merchant navy officer was attending a wedding.

Photographs were a means of publicity, and charities such as the RNLI were eager to sell postcards of lifeboat crews to help raise funds and keep the organisation in the public consciousness. An example of this can be seen in Figure 108. Commercial organisations also used photographic images for publicity – especially the larger shipping companies who wanted their captains to become well-known. A captain of a liner in the Victorian era often had his photograph taken to promote an image of the respectable gentleman (see Figure 12), and a common type of postcard in the twentieth century features a picture of a passenger ship with an inset showing

the captain as well. The seafaring military were not above using images in the press to convey something about their dignity and authority, and Figures 58 and 74 are examples of photos taken specifically for the Victorian press. In wartime such images abounded and were often printed as postcards with suitably patriotic captions.

Sometimes photographs of the crew and/or their ship were organised to send home as greetings cards or Christmas cards. Figure 9 is an example of a greetings card featuring a Royal Marine from the era of the First World War. The sitter would have had a number of these produced to send to family members and friends. Note the globe and laurel badges on his cap and collar – the emblem of the Royal Marines Light Infantry – and the large anchor fouled with a rope, which was the traditional symbol of the Royal Navy of which the marines are a part.

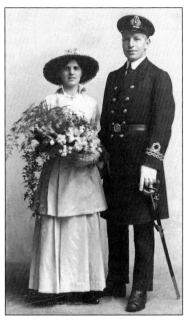

8. Marriage was an opportunity to wear your best uniform, as this naval reservist demonstrates, 1920s.

Particularly in the run-up to the First World War, many men in the Royal Navy and merchant service had photos produced bearing the legend 'forget me not' or similar such phrase. These allowed family members or sweethearts to honour their men's contribution to the war effort while they were away at sea. As such, these images are often accompanied by patriotic emblems such as the Union Jack, as seen in Figure 10. This picture dates from 1914 and note that it has a horseshoe inscribed at the bottom of the lifebelt for luck, together with an anchor and a heart. The man in the photograph is clearly a sailor, but his uniform could be from the Royal Navy or merchant service. However, the background superimposed on the image by the photographer provides evidence that the sitter served with the Royal Navy as it includes a ship's guns, a warship at sea and the King's crown at the top of the lifebelt. Another example of a photographer's standardised

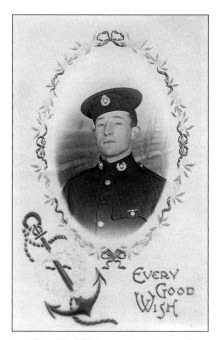
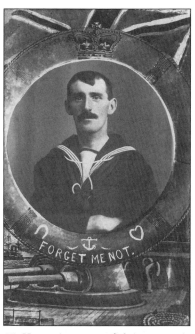

9. A First World War era 'greeting card' photo.

10. Honouring a man fighting at sea in the First World War.

naval background can be seen in Figure 102, where a naval reservist is shown standing in front of a painted curtain depicting a warship's deck. Figure 5 also shows how photographers could create a nautical theme in a studio with props.

When the worst happened and a seafarer died at sea, families and crewmates alike might produce photos to honour the victim's memory. These 'memorial' postcards or photos can apply to all the seagoing professions – fishermen lost in a gale, sailors who died at sea, lifeboatmen who perished trying to rescue others. Sometimes copies of an old image were made and sold to raise money for the victim's family or produced as a keepsake to honour the memory of an individual. In this latter case the words 'died at sea', 'in memoriam' or a similar phrase may be printed on it or hand-written on the back by relatives. On other occasions the details of the victim's deeds or the manner of their death may be described. Photographs of a memorial service or funeral are also sometimes seen. Figure 11 shows a memorial image of a much-loved colleague: able seaman Reginald Shephard of HMS *Diomede*, who drowned

aged just 21 at the port of Weihaiwei in China in 1925. The Royal Navy allowed its personnel to wear a black crepe band around the upper left arm when in mourning and this can sometimes be seen in photos.

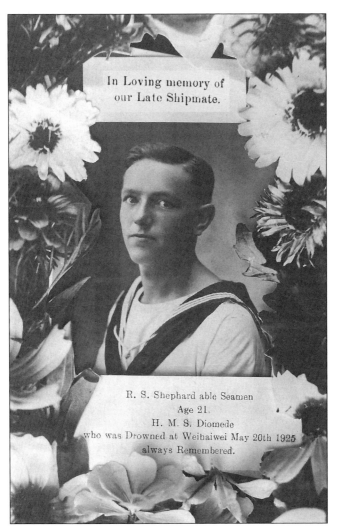

In Loving memory of our Late Shipmate.

R. S. Shephard able Seamen
Age 21.
H. M. S. Diomede
who was Drowned at Weihaiwei May 20th 1925
always Remembered.

11. Memorial photo of Royal Navy Able Seaman Reginald Shephard who died in service, 1925.

Chapter 2

MERCHANT NAVY

The merchant navy differs from the Royal Navy in one particularly important respect when it comes to analysing photographs of its seafarers – there was more than one employer. The Royal Navy had dress regulations that applied across the board to all its employees, but the merchant navy was operated by hundreds of different shipping lines. These varied in size from large, prestigious, oceangoing concerns such as the White Star Line and Cunard to small local companies that operated one or two modest coastal vessels.

The diversity of employers meant a whole host of different attitudes to uniform, and this must always be borne in mind when analysing merchant navy photographs. Some companies were quick to adopt a standardised, smart method of dress, others were not; many shipping lines initially only required their officers to wear a uniform. Needless to say, the details of each employer's uniform, where it existed, differed markedly between companies in terms of appearance and its method of depicting role and rank.

As noted in the opening chapter, there were certain occasions when a seafarer was particularly likely to have a photograph taken. In the merchant navy, studio portraits taken by a professional photographer were common when an employee:

• Started or completed their apprenticeship (apprentice officers were often called cadets).
• Was appointed to their first 'proper' wage-paying position with a shipping company.
• Earned a new role with a prestigious company or ship.
• Went abroad for the first time, especially if it was somewhere exotic or far away.

- Passed their exam to become a ship's mate or master ('captain').
- Was appointed to their first position as ship's captain.
- Was a captain working for a company that required publicity photos.
- Earned an award of some kind.

Merchant Navy Officers

Photography in the late 1850s and early 1860s was comparatively expensive so the principal civilian seafarers captured on camera tend to be the wealthier subjects such as the captain or senior officers.

Most early photographs of senior merchant navy officers from passenger ships do not tend to show them in uniform, but smartly dressed in the fashionable clothes of the period. There was a good reason for this. Photographs were used to promote the concept of the officers on board as 'gentlemen', with the captain at their head.

12. Merchant navy captains, c.1860.

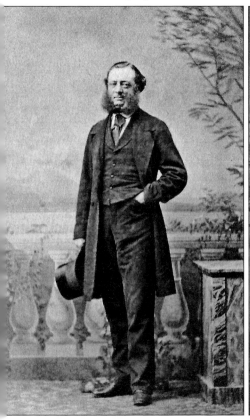
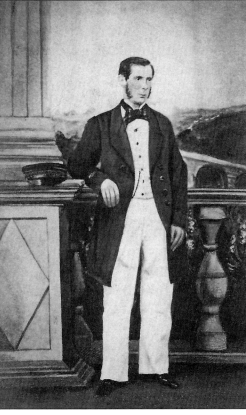

Merchant navy captains were appointed primarily because of their skill in handling a ship and its crew, and not necessarily for their social graces with passengers, yet ship-owners who ran passenger ships liked to portray their captains as elegant, successful and well-educated men in order to attract custom. Hence the marketing of a vessel as a desirable means to travel from A to B in the mid-Victorian period often involved promoting the captain as well as the ship. Everyone on board should aspire to meet the ship's captain, to no doubt listen to a few well-crafted nautical tales and even eat at his table. Figure 12 shows two typical examples from about 1860. The man on the left is Captain Robert Joy, a well-known and popular ship's master.

Note that Captain Joy wears a long frock coat, with a waistcoat and cravat, and he carries a top hat. His dress and the full-length studio portrait is typical of the 1860s. The man on the right in Figure 12 is a merchant ship's captain from the same period. He is wearing a uniform of sorts, but it bears no identifying marks of his employer. His cap on the pillar by his right arm, for example, carries no badge to indicate a shipping line. Ship's captains often moved from vessel to vessel quite regularly and so any uniform that an officer wore was usually purchased by the man himself and had to be quite generic.

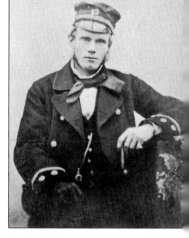

This is not to say that photos of merchant navy officers in uniform do not appear during this period. They do, but they are not common. Figure 13 depicts Basil Wood Pike and was taken in 1858 when he was third mate of the *Skimmer of the Sea*. It illustrates a number of features of officers' uniforms that were to persist down the decades as the fashion for a uniform became more widely adopted. His cap bears a copy of the ship-owner's house flag in miniature. In these early photos, the details of the cap badge are often frustratingly indistinct. The gold braid used could reflect the photographer's flash and hence the

13. Basil Pike, a third mate, 1858.

badge is often bright and over-exposed, or it may be blurred because of the long exposure times, making it difficult to identify details. The other frustration is that there is only limited published information available to help identify house flags from this period.

Even so, there is usually sufficient detail in photos of this era to differentiate between a merchant navy cap badge with its house flag and the very distinctive crown-topped anchor employed by the Royal Navy (see Chapter 3). The officer in Figure 13 wears a quite loose-fitting jacket and the neckerchief indicates a more informal appearance than his Royal Navy equivalent. As in the Royal Navy, officer status and the man's precise rank is shown in this case by cuff stripes. Here, one stripe is known to indicate Basil's position as third mate. The close-up, three-quarter-length pose is typical of that of the 1850s; photos of the 1860s tend to be full-length, more distant poses (compare with Figure 12).

By the late 1860s and 1870s, photos of merchant navy officers in recognisable uniforms become more common. This happened because large shipping lines – especially those that carried passengers – began to adopt standard uniforms that were promoted as part of their corporate identity. Photography itself had also become cheaper and more accessible. The uniform became an important method of acknowledging the seafaring expertise of the wearer and his societal position as well as his seniority on board ship.

To some extent, uniforms in the merchant navy reflect a growing professional pride among those who wore them. After 1850, for example, the ship's captain – or more precisely the ship's *master* – could no longer be appointed solely at the discretion of the owner: this role could only be awarded to men who had earned a national certificate. The certificate required the candidate to submit evidence of suitable previous service for scrutiny by an expert panel, or he could sit an examination. A similar system was introduced for the position of mate as well. Thus, it may fairly be said that the wider adoption and promotion of uniforms was a sign that merchant navy officers were beginning to acquire greater recognition for their professional status.

Figure 14 shows a junior officer sporting the uniform of the

Peninsular and Oriental Steam Navigation Company (P&O) in the late 1860s. Note the long knee-length frock coat with six pairs of gilt buttons, mirroring the elegant but more informal attire of the captains in Figure 12 just a few years before. It also has a strong resemblance to the uniform of Royal Navy officers at this time (see Chapter 3). The overall impression, in fact, is of a 'military like' appearance.

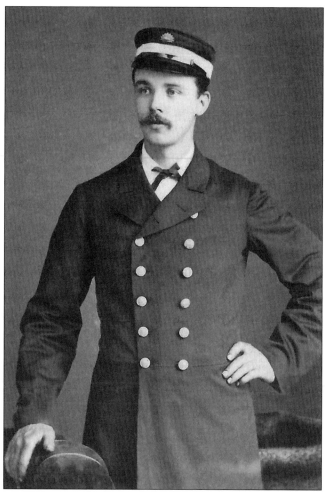

14. A junior officer on the staff of P&O, late 1860s.

P&O has existed since 1837 and was one of the first large shipping companies to mandate the wearing of a standard uniform. Perhaps because they were early implementers, P&O adopted a cap badge and house flag that did not match, which was very unusual. The house flag was a rectangle divided by diagonal lines into four equal triangles, each of a different colour, yet the company's cap badge was a gold rising sun design, as seen in Figure 14. Note that the officer's cap also sports a pale band running around it, which was another distinctive P&O feature at the time. This officer shows no markings of rank, and his relative youth suggests that this photo was probably taken on his first appointment as a junior officer.

A long frock coat was soon recognised as not an especially practical garment for a seagoing officer in the merchant service, and by the 1870s it was largely abandoned in favour of a short jacket that ended just below the waist. The style of the jacket varied over the ensuing decades, but it was here to stay and has remained a core element of the merchant navy officer's dress ever since.

Figure 15 shows an officer of the British India Steam Navigation Company in 1873. Note the especially wide lapels which were fashionable in the early 1870s. When buttoned, the jacket leaves only a small 'v' of shirt exposed, and the patterned neck tie has a wide, loose knot. The cap badge of the shipping line is quite elaborate and depicts Britannia holding a shield and trident standing in front of a lion. It illustrates the intricate designs that some companies created to identify themselves.

Where a cap badge is visible, it is often the sole means for identifying an ancestor's shipping line. Although there is no source that describes a comprehensive range of merchant navy cap badges,

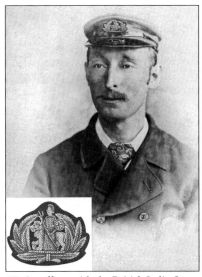

15. An officer with the British India Steam Navigation Company, 1870s.

almost all of them were based on the company's house flag. A variety of publications has depicted these flags over the years and they are

very helpful in identifying cap badges. Many were published as a series of books, and they include:

- James Griffin. *Flags: National and Mercantile – House Flags and Funnels* (Griffin & Co., 1st edn 1883).
- Thomas Reed. *The House Flags and Funnels of the English and Foreign Steamship Companies and Private Firms* (Thomas Reed, 1st edn c.1890).
- Anon. *Lloyd's Book of House Flags & Funnels of the Principal Steamship Lines of the World and the House Flags of Various Lines of Sailing Vessels* (Lloyd's, 1904 and 1912).
- F.J.N. Wedge. *Brown's Flags and Funnels of British and Foreign Steamship Companies* (James Brown & Sons, 1st edn 1926).
- E.C. Talbot-Booth. *House-Flags & Funnels of British and Foreign Shipping Companies* (D. Appleton-Century Co., 1937).

A number of websites also display examples of shipping company house flags including www.crwflags.com and www.rmg.co.uk/researchers/collections/by-type/flags. House flags utilised a variety of colours and distinctive shapes, and incorporated letters, geometric shapes and pictures. Figure 16 illustrates some common examples in use in 1912. All of these flags were adopted as cap badges to identify company personnel. For officers the flag was usually surrounded by leaves woven from gold braid, as seen in Figures 1, 2, 18 and 20, and in the photos of cadet officers in Figure 26.

Occasionally it is possible to identify the shipping line logo on buttons in an old photograph. Most of the time the polished metal buttons are 'whited' out by the flash used in studio photography but sometimes they are clear enough to aid identification of an ancestor's employer. Examples of buttons from shipping line uniforms can be seen in Figure 17; the designs on them are often a variant of the cap badge. The P&O button, for example, has the characteristic rising sun design seen in the cap badge in Figure 14, but appears above a fouled anchor on this company button, while the British India Steam Navigation Company button shows Britannia and the lion as on its cap badge, but on the button the letters

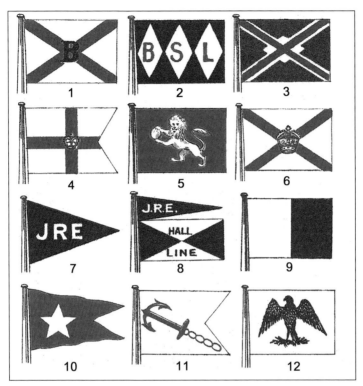

16. A selection of house flags used by shipping lines, 1912. Booth Steamship Company (1), Bucknall Steamship Lines (2), Union-Castle (3), African Steamship Company (4), Cunard (5), Royal Mail Steam Packet Company (6), Ellerman Line (7), Hall Line (taken over by Ellerman; 8), Brocklebank Line (9), White Star Line (10), Anchor Line (11), American Line (12).

'BISNCo' can also be seen. The other buttons in Figure 17 simply show the company's house flag, but some include the initial letters of the company's name as well. Note that buttons, like every other aspect of the merchant navy uniform, changed in design over time.

Some companies appear to have been quite rigid in what was deemed acceptable dress for their officers, laying down strict dress codes, as did the Royal Navy. Others were more relaxed, and it is not uncommon to find group photographs of officers working for the same shipping line where a number of different variants are on

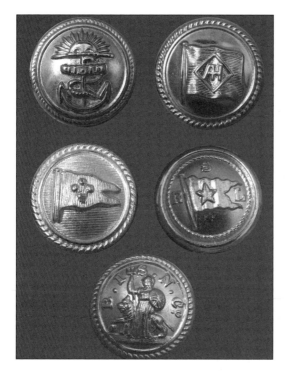

17. Distinctive jacket buttons used by shipping lines may be discernible in photographs. This illustration shows P&O (top left), Ocean Steamship Company Ltd (also known as 'Alfred Holt & Co.'; top right), Prince Line (middle left), Red Star Line (middle right) and British India Steam Navigation Company (bottom).

display together. This was perhaps in part determined by whether the shipping line provided the uniform or whether the individual had to pay for it himself! Merchant navy personnel were typically only employed for one voyage at a time, so officers often bought a generic cap and jacket to which any company badges and so forth could be stitched as required.

It is generally the case that officers on sailing ships and cargo vessels were less likely to wear a company uniform than their equivalents on passenger-carrying steamships. This persisted right up until the early twentieth century. If the captain wore a uniform of sorts, it might only be a 'generic' officer-like jacket with a peaked cap and no particular company identification or marks of rank. The crews of sailing ships and cargo vessels are also less commonly photographed than their oceangoing, passenger-carrying counterparts.

Officer Types and Seniority

Shipping lines employed various types of officer, but these might broadly be classified in two groups: 'deck' officers and specialists. Deck officers were headed by the captain and were responsible for the overall navigation, safety and working of the ship. In the nineteenth century, the captain's immediate subordinate was usually called the first mate, and under him the second mate and so on. Sometimes there was a rank of chief mate in between the captain and first mate. Figure 18 shows a senior officer with the Liverpool-based Moss Steamship Company in about 1905.

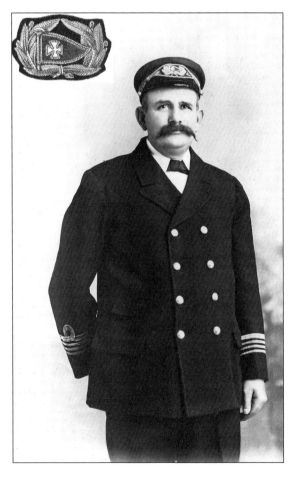

18. A captain with the Moss Steamship Company, c.1905.

The officer's rank is indicated by his four cuff stripes, which in this case are similar to those adopted by the Royal Navy in that the uppermost ring has a loop or 'curl' in it. Where used, the presence of these loops in cuff stripes often indicates a deck officer. Shipping lines could adopt very different approaches to indicating officers' ranks – some copied the cuff stripes or 'distinction lace' of the Royal Navy exactly, others developed their own versions with or without loops, or they employed shoulder stripes instead. Often four stripes with a loop in the uppermost stripe indicated the rank of ship's master, known variously as the 'captain' or 'commander'. The most senior mate then usually had three stripes, and so on down to the most junior officers who often had no stripes. The subject in Figure 18 is a captain; some shipping companies seem to have used only three stripes to indicate this rank.

Another technique commonly seen for indicating seniority among ships' officers was the use of gold bands encircling the cap. The more of these there were, the more senior the officer. If the captain had four, the first mate would have three and so forth. But again there was no uniformity and some captains had only three bands. A particularly good example of a senior merchant navy officer with bands on his cap to indicate rank can be seen in Figure 19. This man is believed to have been employed by a small Sussex shipping company, but his identity and the name of his employer have not been confirmed. However, in group photos the counting of bands on caps can be a good way to sort officers by rank as their sleeves may not always be visible. The officer in Figure 19 has a flower in his buttonhole so this photograph may have been taken on a wedding day.

19. A merchant navy officer, c.1890. His rank is indicated by stripes running around his cap.

A final indicator of rank on merchant ships was the use of gold on the peak of an officer's cap. As in the Royal Navy, this distinction tended to be reserved for the most senior officer on a ship. Not all shipping lines used it, as Figures 18 and 23 bear witness, however

where it was used it was generally the captain's privilege, as can be seen in Figure 43.

Apart from deck officers, there were also specialist officers on board merchant ships which in various eras could include engineers, surgeons and electricians, for example. By the twentieth century, the most senior stewards also became officers.

Figure 20 shows an engineer who worked for Clan Line. This company's uniforms were so similar to those of the Royal Navy that Clan Line employees were referred to as 'The Scots' Navy'. This picture was taken in about 1900 in Glasgow, and it was not common at that time to see a black ship's officer in Britain. Another engineering officer can be seen in Figure 41: this time a junior officer with one cuff stripe working for Bucknall Lines in 1902. Figure 1 is

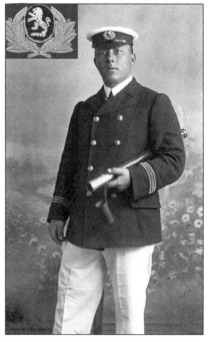

20. A senior engineer officer working for Clan Line, c.1900.

probably a third example. You will note that none of these engineering officers has a loop or curl in his cuff stripes.

While deck officers might have loops in their cuff stripes, if their employer adopted this convention, it was less common to see loops used by specialist officers. In many respects the merchant service took its lead from the Royal Navy and in the nineteenth century only deck officers in the navy took the curl. The merchant navy also used particular colours to depict certain types of specialism – an idea again borrowed from the Royal Navy. The front cover of this book, for example, shows a man with gold cuff stripes in between which are red stripes. Traditionally, this red colour indicated a ship's doctor – who was often known for historical reasons as its surgeon. His cap badge indicates that he was employed by the African Steamship Company (the flag on which his cap badge is based can be seen in

Figure 16). Generally, purple stripes indicated engineers, and white stripes were used for ships' pursers. These colour conventions were later continued when a national uniform for the merchant navy was introduced in 1919.

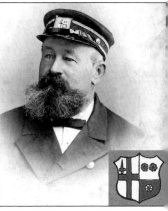

It should be borne in mind when analysing photos of merchant navy officers that a number of other organisations could operate seagoing vessels apart from 'conventional' shipping lines. Figure 21 shows an example of a ship's officer employed by the London and South Western Railway. The complex cap badge is quite distinctive and is in the form of a shield, rather than a house flag. This company ran a

21. A ship's officer working for the London and South Western Railway, 1890s.

fleet of ships that enabled connections between its railway stations on the coast with ports that were usually comparatively nearby. The London and South Western Railway, for example, ran ferries that enabled passengers who took one of their trains to Southampton to make a direct connection to French ports and the Channel Islands.

Similarly, it is not uncommon to find the coat of arms of a local town on the cap badge of an officer if the corporation owned and ran, say, a local ferry.

War and Changes

In the First World War, the merchant service was put under enormous strain. Its non-combatant officers and crews continued to sail ships into waters where they knew that U-boats and German raiders operated. This unstinting bravery earned the service a new level of respect since without the supplies of food, equipment and raw materials brought in by merchant ships, Britain might have been forced to capitulate.

By 1918, many merchant seamen had already lost their lives, but the government introduced a method of honouring men who had survived being on board a ship that was torpedoed or mined. This took the form of a torpedo worn on the cuff of the left sleeve. A bar

was added for each subsequent attack that was survived. These 'badges of courage' were equivalent to the wound stripes awarded to men on the Western Front (see Figures 69 and 106). Figure 22 shows three young merchant navy officers, and the man on the right has a torpedo plus two further stripes on his left cuff. This indicates he was on board three different ships that were torpedoed or mined.

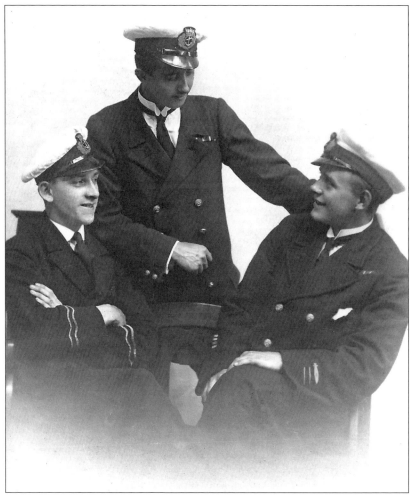

22. Three merchant navy officers, c.1920. The man on the left is a second radio officer, the man on the right was torpedoed three times in the First World War.

It was only after the First World War ended that many people recognised the true extent of the merchant's navy's brave and vital contribution to the war effort. In 1919, as part of a tribute to the service's conduct during the First World War, George V introduced a national uniform for its officers. Unlike the Royal Navy's national dress, it was not compulsory to wear the merchant navy uniform, but after some initial reluctance, many of the bigger shipping lines did adopt it. Figure 23 shows the national uniform for a merchant navy captain as photographed in 1925. Note the diamond shape that now appears as the most characteristic element of the cuff stripes. His cap also displays the national badge for the service consisting of an anchor in an oval, surrounded by leaves, and surmounted by a pointed crown. The men in Figure 22 are wearing the cap badge of the national uniform as well.

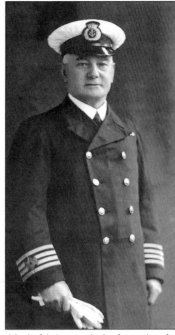

23. A ship's captain in the national merchant navy uniform introduced in 1919.

The cap badge is shown in close-up in Figure 24 and compared with one example of a Royal Navy officer's cap badge. Note that the Royal Navy's anchor is chunkier and is fouled by a chain, while the slimmer bare anchor of the merchant navy cap badge is

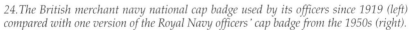

24. The British merchant navy national cap badge used by its officers since 1919 (left) compared with one version of the Royal Navy officers' cap badge from the 1950s (right).

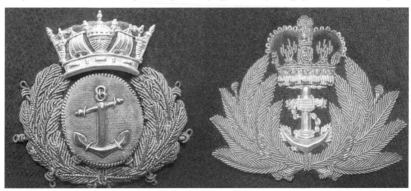

surmounted by a different style of crown of a more ancient design than the one used by the Royal Navy. These differences can often be picked out in photographs using a lens and are an important means of identifying which seafaring service employed an ancestor.

Examples of how rank and role were designated by the national uniform for merchant navy officers are shown in Figure 25. The uniform jacket was blue and the cuff stripes were gold. Engineers, surgeons and pursers were identified by each having a unique additional colour incorporated into the cuff stripe to indicate their specialisation. The hashed areas in Figure 25 represents these colours

25. Cuff stripes for officers used by the merchant navy nationally since 1919.

Captain

Chief Officer

First Officer

Second Officer

Third and Junior Officers

Chief Engineer

Senior Surgeon

Senior Purser

Radio Officer

Chief Steward

– purple for engineers, red for surgeons and white for pursers. Unfortunately, although white is generally easy to see, the purple and red areas do not show up in black and white photographs.

Note that the chief engineer often had a range of junior officers – second engineer, third engineer etc. – whose ranks were denoted similarly to deck officers but with the red colour incorporated in the relevant cuff stripe. In the same way, the senior purser was in charge of pursers and assistant pursers, and the surgeon had assistant surgeons at his command.

Many shipping lines adopted the national uniform only partially. Most commonly this took the form of using the designated cuff stripes with their diamonds, but continuing to use the company's own cap badge rather than the national one.

Cadet Officers

Apprentice officers were usually called cadets and they were photographed frequently since these new recruits were keen to be immortalised in uniform. Their most obvious characteristic in old photographs is their youth. However, cadets by and large wore a uniform during their training that sported the company's cap badge, which makes them identifiable. There was a tradition in many shipping lines that cadets should wear three gold buttons running across the cuff to distinguish their junior status, but not all companies adopted this, as can be seen in Figure 26. This image shows cadets employed by different shipping lines over a thirty-year period from 1880 to 1910.

When comparing the four cadet photographs, note the variation in neckwear, shirt collars and jacket designs consistent with the fashions of the periods concerned. The cap design is remarkably consistent throughout this period, with its polished leather peak and double cord straps. However, the overall shape of the cap becomes fuller with time, especially the topmost part or 'cover'. These can be helpful dating clues in the absence of other information. Some of these cadets bear the traditional three cuff buttons designating their cadet status and some do not. These buttons tend to be seen more consistently in photos dating from the 1890s onwards.

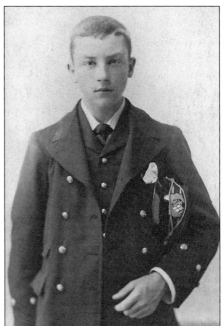
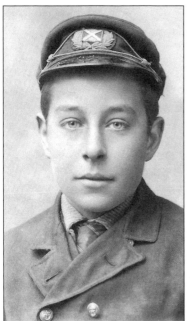
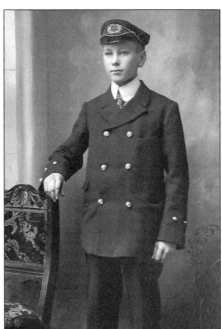

26. Cadet officers. Their employers were George Smith & Sons or 'City Line', 1880 (top left); Shaw Savill & Albion, 1892 (top right); Australasian United Steam Navigation Company, c.1900 (bottom left); and John T. Rennie & Sons, 1910 (bottom right).

Some officers were educated on training ships before joining a shipping line and these establishments sometimes had their own uniform and distinctive cap badges. For example HMS *Conway* was originally based on the Mersey and trained young men for both the Royal Navy and merchant navy. A cadet wearing the distinctive *Conway* cap badge in about 1925 is depicted in Figure 27. Note the button and twist of white braid in the collar of his jacket in the naval style to indicate his trainee status. Compare this to the naval cadet in Figure 59.

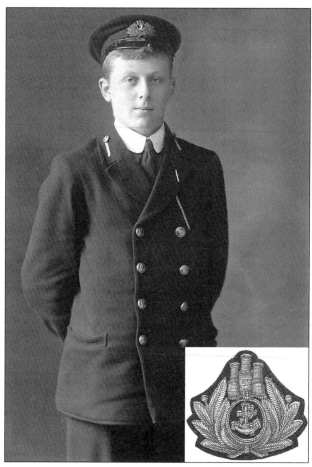

27. An officer cadet from HMS Conway, *c.1925.*

Telegraphers and Radio Officers

The predecessor of radio was telegraphy, which provided the means to send Morse code messages over the airwaves between ship and shore, or ship to ship. It began to be installed on commercial ships in 1903. Early telegraphers were trained by the Marconi Company and they were hired out to vessels one voyage at a time. For this reason they were known as 'Marconi men', and they were used by most of the large shipping lines of the early twentieth century including White Star and Cunard. Figure 28 shows a ship's telegrapher working for Marconi in 1910. The officer at extreme left in Figure 32 is also a 'Marconi man'.

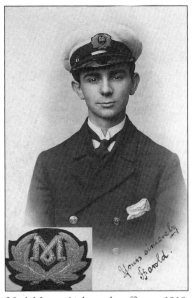

28. *A Marconi telegraphy officer, c.1910.*

Note the large and ornate letter 'M' which constitutes this man's cap badge, and the same letter is also clearly visible on his jacket buttons. This 'M' stands for Marconi and *not* master – in other words it is not an indication that the man is the ship's captain. This is the uniform that the brave radio officers of the *Titanic*, Jack Phillips and Harold Bride, would have worn as they stayed at their posts desperately sending out the international distress signal while the ship slowly began to sink.

However, during the 1910s some shipping lines began to employ their own radio or 'wireless' officers and when the national merchant navy uniform was introduced in 1919, radio officers had their own distinctive appearance. Their cuff stripes had a characteristic wiggly design, although the diamond insert was retained for the post of first radio/wireless officer. Figure 29 shows a first radio officer in 1945 in the national merchant navy uniform; his medal ribbon is the 1939–45 Star.

The post of second radio officer was indicated by two wavy stripes on the cuff without the diamond, and an example of this can be seen in Figure 22, where the man on the left is a second radio officer. A

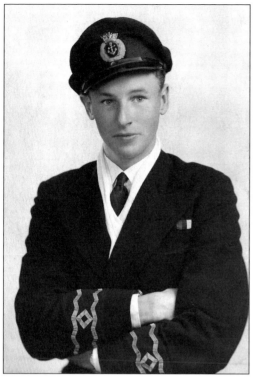
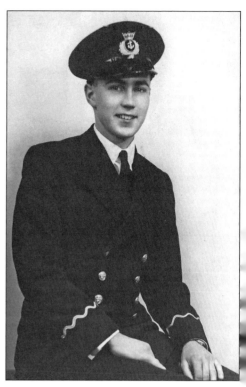

29. First radio officer William Walters, 1945. 30. A third radio officer, 1938.

single wavy stripe without a diamond was a third radio officer and this position is depicted in Figure 30. Note that the distinctive merchant navy cap badge helps to distinguish the radio officer in Figure 30 from civil branch officers in the Royal Naval Volunteer Reserve who also adopted 'wavy' cuff stripes (compare with right-hand image in Figure 87).

Steward Officers

Although the national uniform for merchant seamen featured stars on the sleeve to distinguish senior stewards (Figure 25), many shipping companies chose not to use them because they were too similar to the buttons worn by officer cadets (see examples in Figure 26). A popular way to identify the chief steward and his most senior officers was the use of zig-zag lines on the cuff. The man on the left in Figure 31 is a senior steward not wearing the national uniform and he has zig-zag stripes on his cuffs; the man on the right is a second officer in national uniform. The number of zig-zags denoting

the most senior steward was usually two or three, depending on the shipping line.

Women in senior roles on a ship were fairly few in number, and a uniform for the senior stewardess was slow to appear in many shipping lines. Figure 32 shows the officers on board a ship of the Bucknall Steamship Company in 1907. Unlike the male officers, the centrally placed senior stewardess does not have a uniform with any insignia of rank. Many of the male officers have stripes running along the cuff, rather than across it, to indicate their seniority.

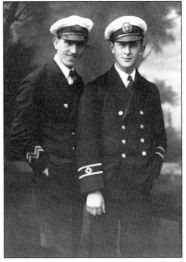

31. A senior steward with zig-zag cuff stripes (left) and a second officer in national uniform (right), 1930s.

32. Officers in uniform on a Bucknall Line ship, 1907. Note the senior stewardess and the man standing extreme left, a Marconi radio officer.

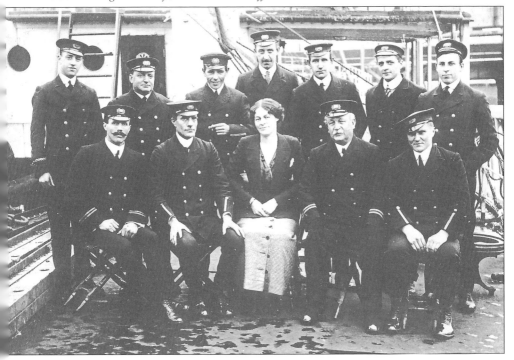

Merchant Navy Seamen

Photographs of merchant seaman from the 1850s and 1860s are rare because photography in this era was expensive and beyond the means of many working men. However, some images survive. Figure 33 shows a seaman in the late 1850s. He does not wear a uniform, as was usual during this time. His clothing shows some features typical of merchant seamen – a knitted jersey, broad-brimmed hat and a neckerchief. Yet, this apparel can be indistinguishable from that worn by other civilian seafarers in the Victorian era such as fishermen (see Chapter 6).

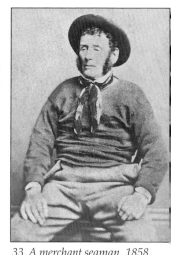

33. A merchant seaman, 1858.

These working clothes did not change substantially, fashion aside, for many merchant seamen until the twentieth century. Many seamen continued to wear practical clothes for warmth and to protect themselves from the sun but no uniform, especially in sailing ships and cargo vessels.

However, this situation gradually changed: initially for seamen employed by the larger shipping companies and particularly those men who worked on steamships that carried passengers. A uniform was a way to create and enforce a corporate image with its associated standards, and shipping lines saw this as a means to encourage loyalty among both passengers and crew. An early example of a seaman's uniform can be seen in Figure 34, which dates from the 1860s. The age of this image is such that some of its aspects have been enhanced digitally to show distinguishing features that might otherwise only be seen after close inspection with a lens. Note that the initials of the shipping line can be seen on both the seaman's jersey and on his cap tally. The letters PSNC stand for the Pacific Steam Navigation Company.

Throughout the nineteenth century, most photographs of seamen tend to be taken in a studio. Cameras were expensive and delicate, and to operate them on the unstable deck of a ship at sea was risky. Hence crewmen photos on board ship are not seen until towards

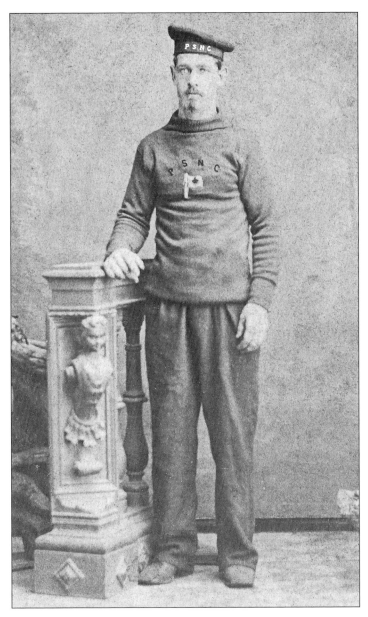

34. A seaman with the Pacific Steam Navigation Company, early 1860s. PSNC appears on his cap tally and on his chest, where it is accompanied by the company flag.

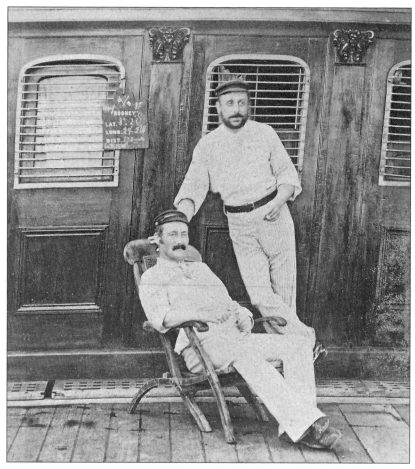

35. Two seaman on Devitt and Moore's Rodney, *c.1880.*

the end of the century. Figure 35 is an exception. It shows two seamen on board the clipper *Rodney*, which ran passengers and cargo from Britain to Australia from the 1870s to the late 1890s. This ship was owned by Devitt and Moore and was an elegant and prestigious vessel. The two seamen are similar in appearance wearing white shirts, pale trousers and black peaked caps, but this is not a uniform. The seaman standing has striped trousers, whereas the man seated does not, and their clothing has no marks identifying

their employer. There are no cap tallies naming Devitt and Moore or the *Rodney*, for example.

Some companies, however, began to provide cap tallies bearing the name of a specific ship, in semblance of the Royal Navy. This was an easy way to provide identity to the crew: seamen simply changed their tally when they changed ships. Figure 36 is an example of this. The overall appearance of this seaman's jersey and cap from about 1900 is quite 'navy like', but there are important differences compared with the Royal Navy's uniform for ratings (see Chapter 3). This seaman is wearing a collar and a striped shirt underneath his jersey as well as a tie, something never seen in serving naval men. His cap tally also clearly names his ship as 'SS Marw . . .' and not 'HMS'; the

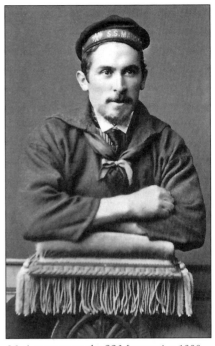

36. *A seaman on the SS* Marwarri, *c.1900.*

initials SS stand for steamship. The tally also depicts the flag of the owners before the ship's name which was quite common. This seaman's ship was the SS *Marwarri*, a vessel operated by Brocklebank Line. Naming a specific ship on a uniform tended to be an initiative preferred by passenger-ship operators rather than cargo ships. Regular workers on coastal passenger ships and ferries sometimes had the ship's name on their jerseys, a practice also seen among yachting crews (see Chapter 6).

As mentioned earlier in this chapter, crews of many sailing vessels and cargo ships did not adopt uniforms. Figure 37 demonstrates that this persisted into the twentieth century. The upper image is of seamen on board the SS *Balmoral*, a transatlantic British cargo ship, in 1893. The wider range of clothing is clearly seen – different jerseys, hats, trousers and neckwear. The two young men sitting on deck at the front are apprentices – this being their traditional place in group

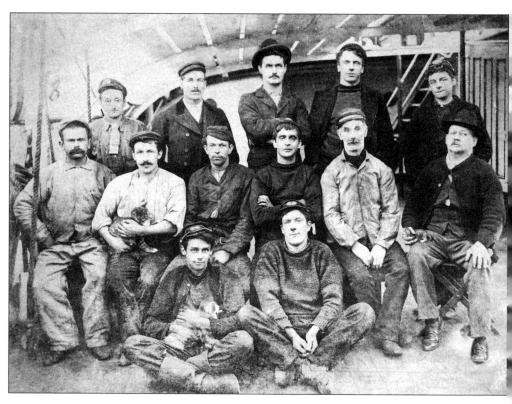

37. Seamen on cargo ships – the SS Balmoral, *c.1890 (top) and the sailing ship* Sheila, *1914.*

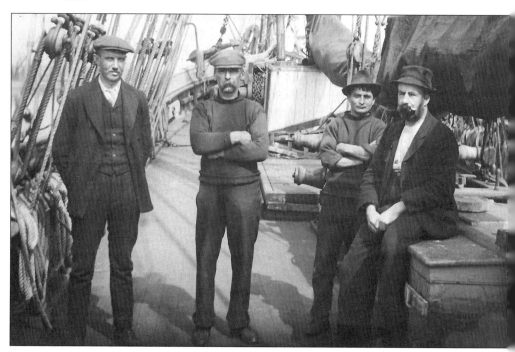

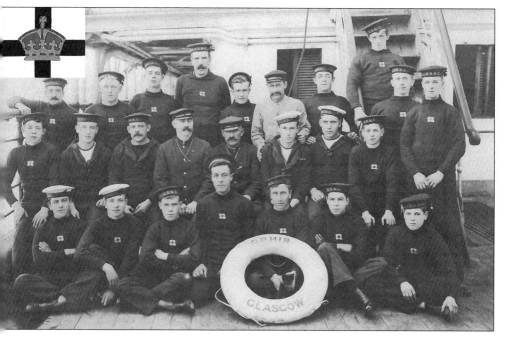

38. Crew of the Orient Line vessel Ophir, *c.1910.*

photos of this kind. They are wearing apprentice caps bearing the shipping line's flag, but this is the only evidence of a uniform. The lower picture in Figure 37 features the crew of a cargo sailing ship, *Sheila*, in about 1914, illustrating that although the fashions have changed, the overall non-uniformed appearance is not that different. Note the slightly 'over-sized' cloth caps, which were prominent in the 1910s.

Meanwhile, the uniforms worn by crews on large passenger ships continued to evolve. Figure 38 shows seamen from the crew of the Orient Line's SS *Ophir* in about 1910. The company's house flag was a large crown set on a cross against a white background and this flag has been woven into the men's jerseys. It is shown in detail as an inset. The lettering 'Orient Line' is just discernible above and below the flag on the men's chests. Their cap tallies bear the abbreviation of the shipping line's formal name – 'OSNC' stands for the Orient Steam Navigation Company.

Seamen from Cunard's RMS *Antonia* are assembled in Figure 39. This photo dates from about 1925, after the national uniform was introduced for the merchant navy. Although no uniform was provided for seamen, note that badges were designated for certain senior positions. The boatswain could wear two crossed anchors on his left sleeve like petty officers in the Royal Navy; the boatswain's mate had a fouled anchor and the quartermaster a ship's wheel. The six men in the photo all display the double anchor of a boatswain on their left sleeve, and all have the word 'Cunard' on their cap tallies. Notice that in all other respects this Cunard uniform for seamen could be difficult to distinguish from that used by the Royal Navy.

Other Merchant Navy Employees

The dress of a ship's stewards and stewardesses varied quite considerably between shipping lines. In the late nineteenth and very early twentieth centuries some stewards wore formal clothes similar to a footman in a wealthy household: waistcoat, tie, jacket. Many stewards wore a smart jacket and tie by the twentieth century, together with a cap bearing the shipping line emblem. There was usually no circlet of gold leaves around their cap badge to distinguish them from officers in the command hierarchy. Examples can be seen in Figure 7 where many of the stewards on the *Demosthenes* are dressed in bow ties, dark jackets and caps. A few ship's officers are sat in the middle – the purser being the central seated figure – and these men have cap badges with a circlet of gold leaves.

Stewardesses were much less common, although they are occasionally captured in group photographs and again can be seen in Figure 7. Their uniforms appear nurse-like and this was a common look for stewardesses in the early twentieth century, and is quite distinctly different from their male counterparts in the same photograph.

As already noted, the most senior stewards or stewardesses had the status of officers by the twentieth century (see Figures 31 and 32).

Many members of the crew who were not officers, seamen or

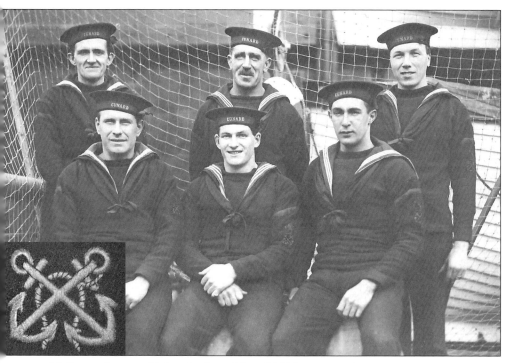

39. Boatswains assembled on the Cunard liner RMS Antonia, *c.1925.*

40. A steward, a waiter, two cooks and an officer on board Leyland Line's SS Memphian, *1915.*

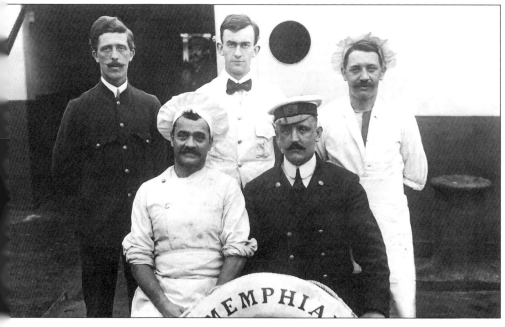

stewards tended to wear clothes similar if not identical to their shore equivalents. Figure 40, for example, shows two cooks and a waiter, as well as an officer and a steward, on SS *Memphian* in 1915. Some catering staff in their white tunics can also be seen in Figure 7.

Although a ship's engineers were classed as officers and adopted a uniform, other engine-room workers on board often wore whatever clothes suited them in terms of comfort while they fulfilled their role. They did not deal with passengers or the public, so it was unimportant for them to adopt any element of the shipping line's corporate identity. The roles of fireman, greaser and trimmer were physically demanding in hot and messy conditions, and so a uniform was impractical. Hence, these men tended to wear overalls for their working day, in the same way that men with similar roles did in the Royal Navy (see Figure 50).

There were traditions regarding the employment of certain ethnic groups in the merchant navy that began in the nineteenth century and persisted until the middle of the twentieth century. These

41. Engineer Fred Harrison on the Pondo *with his engine-room crew from the Indian subcontinent, 1902.*

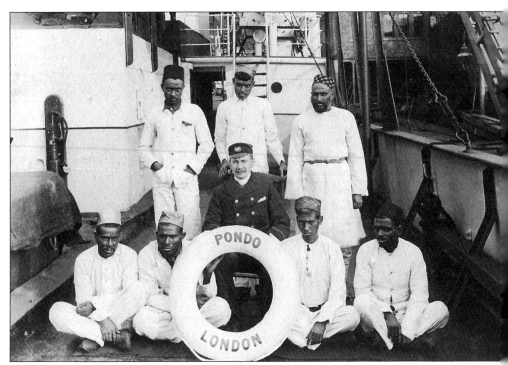

traditions particularly concerned men from South Asia, who comprised a substantial proportion of the workforce: engine-room staff, for example, would often be Muslims from the Punjab or Chittagong areas of the subcontinent. Formal photographs of these crewmen, where smart clothing was expected rather than working apparel, often feature them in their traditional ethnic dress. Figure 41 is an example of this. It shows a white engineering officer surrounded by his team from the engine room in 1902. By 1941, there were over 40,000 Indian men employed by the British merchant navy – this was at a time when the word 'Indian' would have been taken to include citizens of modern-day Pakistan, Bangladesh and neighbouring countries.

Finally, it should be noted that not all men in uniform that look like seamen are seamen. In some locations porters that loaded passenger baggage onto ships wore clothing similar to seamen. Figure 42 shows an example. This photograph depicts a marine porter employed by the South Eastern and Chatham Railway (SE&CR), which can be seen on his cap badge and on his jersey. As already noted, many railway companies ran their own ships (Figure 21) or provided rail links to ports. SE&CR operated trains and ships across Kent and to its ports.

Group Photographs of Crews

A photo of the crew of a merchant ship allows much of the information given in this chapter to be brought together to analyse a group of people. Figure 43 is a typical example.

Examination of this photo prompts the following observations:

1. This is a photo of a merchant navy crew since none of the officers have the distinctive Royal Navy cap badge with its fouled anchor surmounted by a crown (Figure 24), and none of them have naval officer cuff stripes (Figure 55). Similarly, the seamen have no naval insignia of rank, specialty or conduct on their sleeves or lapels (see Chapter 3).

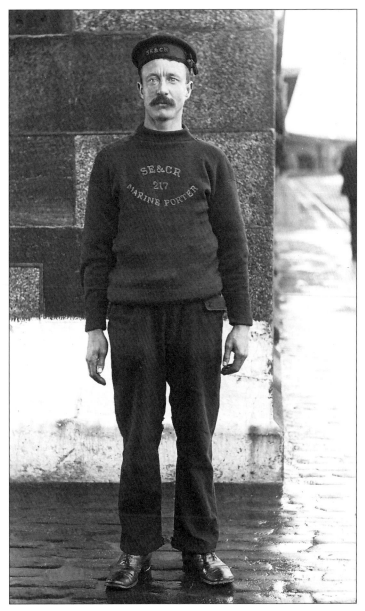

42. Despite appearances, not a seaman – William Sutton, c.1920. He worked as a marine porter for a railway company.

2. The photo was taken by a photographer named Materozzoli in Livorno, which is in Italy. Yet the two lifebelts at the centre of the photo at the back show a ship registered in Glasgow. So this is a British ship based in Scotland that travelled to the Mediterranean.

3. A large rounded white vent at waist height to the right of the man dressed in white shows this was a steamship.

4. The general structure of photos of this type would suggest that the two boys sitting/laying down on the deck at the front are apprentices, as this was traditionally their position in photos. The most senior officers will be the four sat down at the front.

5. All the officers have a cap badge, showing an anchor trailing a chain. The man seated in the centre with a beard is the captain because he is the only one with a gold band on the peak of his cap. He also has a thin braided gold epaulette on each shoulder. The man seated to his right has two epaulettes but no gold on his cap and so is probably the next most senior officer (e.g. first mate); the man to the captain's left has only one epaulette and so is probably the third in command (e.g. second mate).

6. The two officers standing one at each end of the seated officers are probably junior officers. The man in white to the right of the photo is probably the chief steward. Note that although the officers wear the same cap badges, their jackets and neckwear are all different. This shows that they probably bought their own uniforms – a 'standard' jacket was not provided by their employer.

7. The seamen standing behind the officers all have a white, forked flag on their chests bearing an anchor that trails a chain. This is the flag of Anchor Line, a shipping company based in Scotland. The flag can be seen more clearly in Figure 16.

Some of the men also have this emblem on their left sleeves. The phrase 'Anchor Line' is just discernible on the cap tallies of some of the crewmen.

8. The neat uniforms for every crewmember, and the presence of a steward, points to their ship carrying passengers.

9. The ship's name is always shown at the top of a lifebelt and there are four of them in this photograph, but the top of the lifebelt is the part most exposed to the elements so any text here is often eroded. The only lifebelt with readable text in this photo is the one on the far right-hand side. The photo is damaged, but the letters 'ASSYR' can be seen. A perusal of Anchor Line ships shows that the only vessel this could be is the SS *Assyria*, which was launched in 1900 and sold in 1912. So the photo must date from this period. It was a small ship (6,400 tons) that took passengers and cargo to the Mediterranean and beyond.

43. A group photo of a merchant navy ship (analysed in the text).

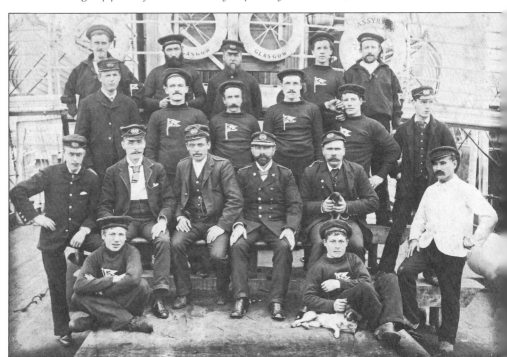

So, analysis of this photo reveals the name of the crew's employer, the ship, the vessel's home port, its role in carrying passengers and part of its route, an approximate date and the likely roles of many of the people featured. Not every photograph will reveal as much information as this.

Example Records for Merchant Navy Ancestors

Records related to careers in this service are many, diverse and complex. They are also spread across different archives including The National Archives (TNA), London Metropolitan Archive, Guildhall Museum (London) and National Maritime Museum (Greenwich) among others. The most up-to-date and comprehensive resource that describes them all is *Tracing Your Merchant Navy Ancestors* by Simon Wills (Pen & Sword, 2012). A small number of example resources are listed below:

• Various national registrations of merchant seamen (1835–57 and 1918–41) held at TNA are available in full via the subscription website www.findmypast.co.uk.
• Ships' masters' ('captains') and mates' qualifying certificates (1850–1927) describe their early careers and are available via the subscription website www.ancestry.co.uk.
• There is a partial online index to Lloyd's Captains' Registers for officers active between 1869 and 1911 available at www.history.ac.uk/gh/capintro.htm.
• Look at the TNA website research guides under 'Merchant Navy' but also read those indexed under 'Crew Lists' at www.nationalarchives.gov.uk.
• Merchant navy personnel who died in either world war are listed on the Commonwealth War Graves Commission website at www.cwgc.org.

Chapter 3

ROYAL NAVY

By studying a photograph it is usually possible to understand the role and rank of a naval employee. Furthermore, while uniform regulations and fashions may help determine the era when the image was created, badges and medals may reveal a specific area of expertise, duration of service and military campaigns in which the subject participated.

The Royal Navy had both a military or 'executive' branch broadly responsible for commanding ships and taking them into action when necessary, and a civil branch which comprised professionals such as surgeons with specialist rather than seagoing or military knowledge. As the Royal Navy embraced technology in the late nineteenth and early twentieth centuries, there emerged an increasing need for new skilled positions within the service to meet new challenges. This required the creation of additional ranks and roles – engineers and torpedo experts, for example. These positions all required distinctive means of identification via their uniforms.

Naval uniforms for all ranks have undergone many changes since the 1850s and, confusingly, each employee has always had a variety of different uniforms to wear depending upon the occasion. Helpfully, the Admiralty issued written regulations regularly to ensure that all commanding officers knew how to comply with their wishes. The introduction of new uniform requirements at specific dates, and the termination of old ones, are extremely useful clues when dating photos of Royal Navy personnel. However, it should be noted that such changes took time to enact in practice, especially in the nineteenth century. Naval officers in far-flung regions of the British Empire, for example, might not learn about updates to regulations for many months, and even when they did they might not immediately have the resources to enforce them. Thus, any dates

described here for significant changes in uniform should be considered approximate when interpreting photographs.

It should also be borne in mind that some naval employees in all eras adopted their own variations on the official regulations – innocently through ignorance or wilfully with a desire to assert their individuality. There has been a long tradition in the Royal Navy of 'individualism' of dress within certain limits, and personnel in all ranks have sometimes flouted or bent official requirements in favour of alternatives that they preferred. This is particularly true in the period before 1891 when there were ambiguities and omissions in regulations, but in this year they were deliberately tightened.

Although it is not possible to illustrate every uniform variation, rank and role in this chapter, I hope I have provided a representative spread of illustrations to help point the reader in the right direction when interpreting an individual photograph. Note that personnel serving in the Royal Naval Air Service and Women's Royal Naval Service (Chapter 4) and in the reserves (Chapter 5) are considered elsewhere in this book.

Seamen

A standard uniform for seamen was not formalised until 1857, although by this time there tended to be some uniformity of dress. Photographs of seamen in the Royal Navy from around 1860 feature the full-length studio poses characteristic of the period. The left-hand photo in Figure 44 shows an example. A compulsory, standard uniform was then a new concept and it usually tends to look rather baggy. The seaman's jersey was known as a frock: note the expanse of material at the seaman's elbow, the very long trousers that drag on the ground around his shoes and the bulging frock tucked into the waistband.

This image demonstrates another 'fashion' clue that always tends to help date images from the late 1850s and early to mid-1860s: the seaman has a long dark ribbon dangling down the left side of his face. This is the loose ends of the ribbon tied around his cap which bears the name of the ship he was serving on – in this case HMS *Gladiator* – and this style is not seen in photographs beyond the 1860s. The ship's name is picked out in bright lettering

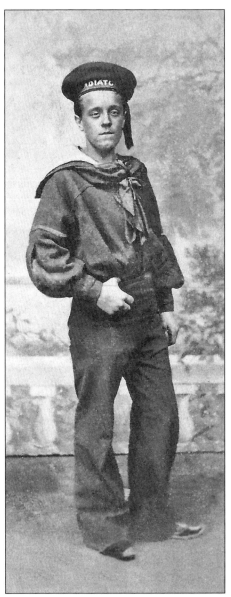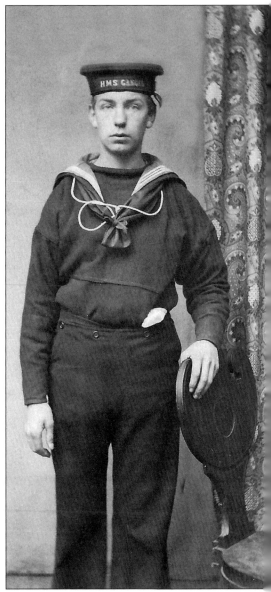

44. Seaman from HMS Gladiator, *c.1860 (left) and seaman from HMS* Ganges, *early 1880s (right).*

against this black ribbon or 'tally', and at this point in time was often painted by hand rather than woven. Two other examples of the long dangling cap tally can be seen in Figure 51.

This seaman has what appears to be a slightly lighter thin band of material on his right arm, where the sleeve meets the body of the frock. This would have been red and so does not show up well against the blue material of the frock, but these stripes were displayed on one arm only. They indicated the side of the ship where a seaman stood watch: men of the starboard watch wore a distinguishing stripe on the right arm; men of the port watch wore it on the left arm. On the white tropical uniform (see below) these watch markings were blue and so tend to stand out more. Watch stripes were abandoned in the late 1890s.

The right-hand image in Figure 44 was taken around twenty years later in the early 1880s. Note that the seaman's frock is less baggy, there is no dangling cap tally and the cap itself has a more rigid shape with a flattened top. Caps from the 1860s were made of softer, unsupported material and looked almost like a 'beret', and thus their shape in photographs is more variable. The frock did not have any pockets so hankies were commonly tucked into the waist – notice the white flap of material hanging out of the waistband – and small possessions, such as a man's pipe, were stored inside the cap. The official line was that frocks should always be tucked into trousers, as seen in both images in Figure 44, and this continued until 1906 when the frock was discontinued.

The seaman's uniform in home waters and temperate climates was basically blue. The frock was traditionally made of a fairly heavy fabric. In hot weather, seamen were allowed to wear a lighter and more comfortable white jumper, accented in

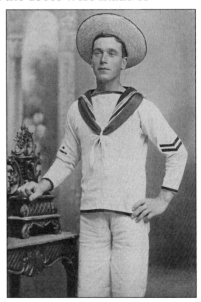

45. Seaman wearing white tropical uniform, c.1890.

places with blue, which was not required to be tucked into trousers. This was introduced in 1880. Figure 45 shows an example from 1890. The distinctive seaman's blue collar with its three rows of white tape can be seen particularly well in this image and also in Figure 48, but is sometimes less easy to see in older images (compare with Figure 44). Part of the reason for this is that the stripes faded with repeated washing.

When the white uniform was worn in the Victorian era it is particularly common to find seamen wearing a regulation straw hat known as a sennet, which can also be seen in Figure 45. This broad-brimmed hat kept the sun off the face and the back of the neck while working, and seamen tied their tallies around it. However, the tally often cannot be seen in photographs because the sennet tends to be tilted backwards away from the camera (but see Figure 51).

There were a variety of different uniforms for seamen. As an example, the Royal Navy Uniform Regulations for 1890 describe *nine* forms of dress, numbered accordingly, with guidance on the circumstances in which each version should be worn (see Table 1).

Table 1: Forms of Dress for Royal Navy Seamen in 1891

Dress no.	In England and in temperate climates	Occasions on which to be worn	Dress no.	Hot climates
1	Serge frock, with gold badges, collars and cloth trousers (*mustering suit*)	At inspections, musters, ceremonial occasions and on Sundays in harbour	6	White drill frocks and duck trousers
2	Serge frock, with red badges, collars and cloth trousers	On leave on weekdays and on Sundays at sea	7	Duck (bound) jumper with collar and duck trousers, or no. 8 dress
3	Serge jumper and trousers and collar	On working days, for all ordinary duties – i.e. usual drills, boat and other ordinary work	8	Serge jumper, collar and trousers
4	Serge jumper and trousers	For night clothing and in wet weather	4	Serge jumper and trousers
5	White working jumper and duck trousers. Check shirt and woollen drawers are to be worn in cold or wet weather and jerseys, if being worn or specially ordered	By working parties, when coaling, refitting, general cleaning of ship and other extraordinary duties when better clothing would be spoiled	9	White working jumper and duck trousers

The nature and numbering of the forms of dress given in the table has changed over time.

Badges

Figure 45 illustrates another aspect of the Royal Navy uniform for 'ratings' – men, including seamen, who were not officers. Badges can be seen on each arm. Seamen wore what were called 'substantive' badges on their *left* arms and these indicate rank and reliability. The seaman in Figure 45 has two large chevrons known as good conduct badges. From 1860 until 1950, one chevron indicated three years of good conduct in service, two was for eight years' good conduct and three for thirteen years. So our man has served at least eight years with good conduct.

46 & 47. Branch badges for navy ratings, 1909. (1) Gunner's mate and gunlayer first class; (2) Gunner's mate; (3) Gunlayer first class; (4) Gunlayer second class; (5) Gunlayer third class; (6) Seaman gunner and petty officer; (7) Torpedo gunner's mate, higher standard; (8) Torpedo gunner's mate; (9) Torpedo coxswain; (10) Leading torpedo man; (11) Seaman torpedo man and petty officer; (12) Chief yeoman of signals; (13) Yeoman of signals; (14) Leading signalman; (15) Signalman; (16) Ordinary signalman and signal boy; (17) Chief petty officer telegraphist; (18) Petty officer telegraphist; (19) Leading telegraphist; (20) Telegraphist; (21) Ordinary and boy telegraphist; (22) Good shooting badge first class; (23) Good shooting badge second class; (24) Good shooting badge third class; (25) Physical training instructor first class; (26) Physical training instructor second class; (27) Mechanician; (28) Chief stoker; (29) All other stokers; (30) Chief and other armourers; (31) Armourers' mates and crews; (32) Blacksmith, plumber, painter first class; all chief and other carpenter's mates, and skilled shipwrights of whatever rating; (33) All other artificers; (34) Naval police; (35) Gold star: schoolmaster, ship's steward, ship's steward's assistant, ship's steward's boy, all writers; silver star: cook; (36) Sick-berth staff.

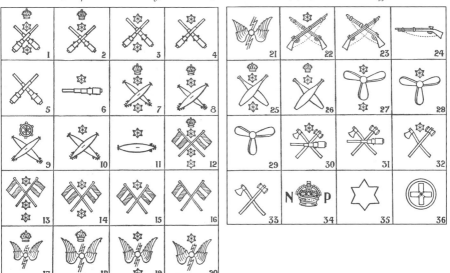

On the seaman's *right* arm can be seen a 'non-substantive' badge depicting his type of duty and level of expertise. These badges are often called branch badges and are always worn on the right arm. In this case, the crewman was a Seaman Torpedoman, his badge being a torpedo with a star above it (see Figure 46).

One of the earliest badges worn by seamen was for gunnery specialists. A first class seaman gunner in 1860 wore a gun with a crown above it on his right sleeve, while a second class seaman gunner wore simply a gun.

Figures 46 and 47 show examples of branch badges in use in 1909. There were a large number of them and it is not possible to illustrate each one here, but these represent some that are commonly encountered in photographs.

Cap Tallies

The ribbon or tally tied around a rating's cap can be very informative. The ship's name almost invariably takes an 'HMS' precursor, although in photos from the 1850s the 'HMS' is often omitted.

'HMS' does not always indicate a seagoing vessel because this designation is also given by tradition to naval shore establishments – or 'stone frigates' – such as air bases, research facilities, training bases or reservist establishments. Many shore establishments started their careers as real ships and later became land-based. HMS *Ganges*, for example, was originally a training ship for boys and so seamen wearing these tallies are often teenagers, but *Ganges* eventually became a shore establishment at Shotley near Ipswich.

The designation of Nelson's old ship 'HMS *Victory*' on a tally was often used for naval employees who did not have a specific ship to operate from – they might have been assigned to naval intelligence or training, for example.

After the First World War particularly, a cap tally sometimes indicated the type of ship served upon, rather than a named vessel and tallies bearing 'HM Submarine', 'HM Destroyer' or 'HM Patrol Vessels', for example, are occasionally seen. A tally may also convey a rating's reservist status and common texts of this kind on tallies include 'RNVR' (Royal Naval Volunteer Reserve), 'Royal Naval

Reserve', or 'Fleet Reserve'. Reservists uniforms are described in more detail in Chapter 5.

If a tally bears simply 'HMS' with no other name this can indicate that the seaman is a new recruit in training and has not yet been allocated to a ship. 'HMS' alone was also used on a tally instead of a ship's name during hostilities for security purposes, although this was not always adhered to in the First World War and is far more commonly seen in Second World War photographs, as evidenced in the right-hand image in Figure 48 and in Figure 80.

When investigating ships whose names appear on tallies it is important to know the approximate date of a photograph because ships' names have been re-used by the Royal Navy endlessly, and you may otherwise research the wrong vessel. There have been nine different ships known as HMS *Arethusa*, for example.

The World Wars

In 1906 the frock was discontinued and replaced with a closer fitting blue serge jersey, which had a pocket on the inside. It was no longer tucked into the trousers. Figure 48 shows examples of this jersey, and compares the uniforms of a seaman from the First World War (left-hand side) and Second World War (1941, right). The uniforms are very similar and it is not always possible to tell them apart in isolation without other dating clues. The white top to the seaman's cap on the left was a removable cover that was worn, when ordered, throughout both conflicts and was not specific to the First World War. The 'bell-bottom' trousers that were part of the very first uniform in 1857 are still present.

The white cord or lanyard round the seaman's neck is usually a prominent feature in photographs of seamen from the First World War and earlier; it tends to be less prominently displayed in Second World War photos (e.g. partially tucked under the black scarf) and is more likely not to be worn at all in photographs. There was a trend for tying the cap tally into rather elaborate bows in the First World War, as demonstrated here. In addition, note the simple 'HMS' on the tally of the Second World War seaman, but that the ship's full name is given in the First World War photograph, as noted above.

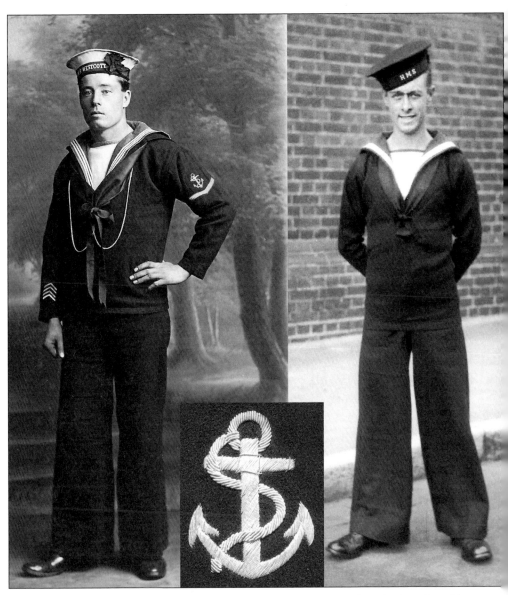

48. *Leading seaman from the First World War (left) and seaman from the Second World War (right). The inset is a close-up of the leading hand's arm badge.*

Increasing numbers of people could afford to own a camera by the 1940s, so there are many more informal photographs of seamen from the Second World War compared with the First World War when most photographs were studio portraits. Figure 48 illustrates this difference.

The image on the left provides evidence that the seaman fought in the First Word War. On his *right* arm can be seen four small inverted chevrons. These are service chevrons or 'war chevrons' and are much smaller than the good conduct badges referred to above, and were worn on the opposite arm. A war chevron was given for each year of service in the theatre of war. They were introduced in April 1918, became optional in 1919 and the wearing of them was officially abandoned in 1922. This image must therefore date to the period 1918–22. The seaman's tally identifies his ship as HMS *Westcott*, which was commissioned in April 1918.

The fouled anchor on his left arm indicates the rank of Leading Hand, and an enlarged picture of this emblem known as a 'killick' is included for clarity. The single good conduct badge below the killick demonstrates at least three years' service with good conduct. These and other badges sometimes don't show up well in photographs because in certain variations of the uniform (e.g. 'Number 2 dress' in Table 1, see above) the badges were red and this provides only limited contrast against a blue uniform in black and white photographs. Always use a lens to check the arms of a seaman for badges.

From 1890, there was also a version of the rating's uniform for men that did not dress as seamen, since the seaman's form of dress was not appropriate for some personnel of equivalent rank who had responsibilities unrelated to the seaman's role. This included writers, certain stewards, shipwrights and sick-berth attendants among others. The uniform consisted of a double-breasted jacket, white shirt with collar, black tie and a peaked cap bearing a red badge. The cap badge was a simple crown above a fouled anchor, and was devoid of any encircling leaves. An example can be seen in Figure 49, which dates from about 1895. These two men were known to be writers as can be verified from the gold star on each of their right

sleeves. Note that the dull buttons on their jackets are made of horn, as opposed to the gilt buttons that would be worn by a commissioned officer or chief petty officer. Other examples of ratings not dressed as seamen can be seen in Figures 84 and 101.

The sennet hat (see Figures 45 and 51) was worn with increasing rarity throughout the early years of the twentieth century, and was finally abandoned in 1921. When protective headwear was needed by men serving abroad, a sun helmet could be provided instead and an example of one design is seen in Figure 94.

Finally, note that seamen wore canvas overalls to protect their uniforms when engaged in messy work such as coaling the ship, painting, refitting and so forth. These were introduced at the beginning of the twentieth century. An example can be seen in Figure 50, which shows four seamen from the engine room of HMS *Europa* in the First World War.

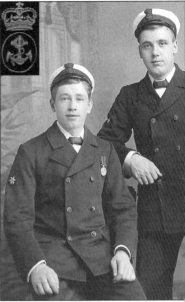

49. Uniform for ratings not dressed as seamen – two naval writers, c.1895. The inset shows the cap badge.

Petty Officers

Petty officers were non-commissioned officers that could be appointed from the ranks – seamen who rose above the position of leading hand. They each acquired a position of authority on account of their specialist skills in a given area. By 1860, there was provision for three classes of petty officer as described in regulations:

Petty officers . . . are to wear an embroidered mark of distinction on the upper part of the left sleeve of their jacket, *viz* –
- Chief petty officers: Crown and anchor, encircled with laurel.
- First class petty officers: Crown and cross anchor.
- Second class petty officer: Crown and anchor.

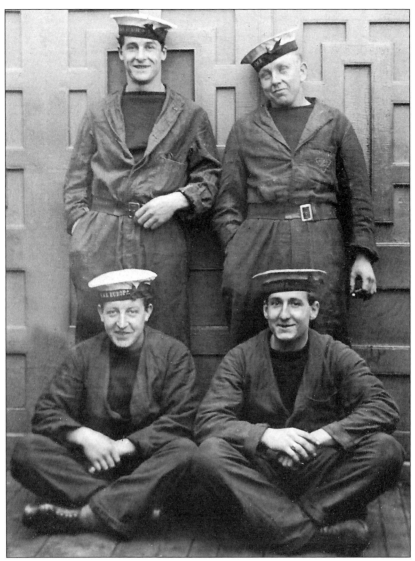

50. Overalls protected the rating's uniform in the engine room or when doing messy work, c.1914.

Figure 51 shows two examples of early petty officers from about 1860. The man on the left is a second class petty officer with the crown and anchor clearly visible on his left sleeve. It is also shown as an inset. His cap shows that he served on HMS *Implacable*, and his long dangling tally and notably 'baggy' uniform is good evidence that this photo dates from the late 1850s or early 1860s, as discussed above.

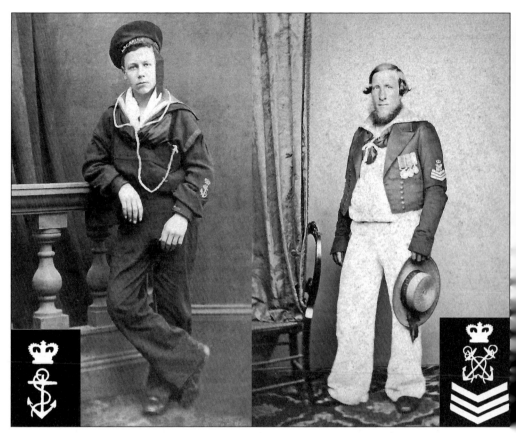

51. Second class petty officer, c.1860 (left) and first class petty officer, c.1860 (right).

The man on the right is a first class petty officer, wearing a jacket over the white frock and duck trousers of the hot climate uniform. He bears two small crossed anchors on his sleeve, which are not very clearly visible in the photo without a lens, but an enlargement is shown as an inset for clarity. He also bears three good conduct badges below the anchors. There was some variation in the appearance of naval badges until 1879 because men could go to any tailor to produce them, or even make their own. The first class petty officer wears a sennet on which the name of his ship is born on a tally which dangles long and loose as per the fashion of the time.

Both of the images in Figure 51 probably date from the late 1850s when badges on blue uniforms were embroidered in white. In 1860 it was decreed that red be used – unfortunately, these red badges are harder to pick out against a blue background in black and white photographs.

Petty officers wore the seaman's white tropical uniform and sennet when ordered, and an example of this is seen on the front cover of this book: a first class petty officer in 'whites' while serving in Hong Kong in the 1890s. This man has a three-bladed ship's propeller and star on his right arm, and so was a chief stoker (refer to Figure 47).

Figure 52 shows a later example of three petty officers from HMS *Mallard* dating from 1912. All of them have two good conduct badges on their left arms. The man on the left is a second class petty officer – he has a crown and anchor on his left sleeve. Note that petty

52. Three petty officers from HMS Mallard, *1912.*

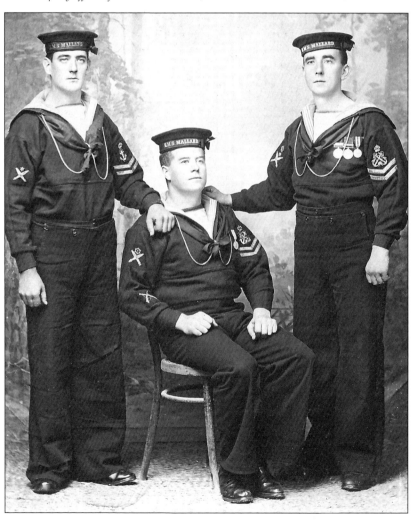

officers were ratings, and wore branch badges as well as seamen. The man on the left has two crossed torpedoes with a star above on his right arm. As detailed in the caption to Figure 46, this shows that he must have been a Leading Torpedo Man. The man sat down in the middle is a first class petty officer since he has two crossed anchors surmounted by a crown on his left arm. On his right arm he has two crossed torpedoes with a ship's wheel above which means he is a Torpedo Coxswain. He also has two crossed rifles on his right forearm: a good shooting badge (second class). The first class petty officer on the right has two crossed torpedoes on his left arm like his colleagues, but there is a star and crown above this badge which identifies him as a Torpedo Gunner's Mate (see Figure 46).

First and second class petty officers persisted until 1913, when the rank of second class petty officer was discontinued. All petty officers from this point onwards wore the uniform formerly allocated to the first class petty officer.

From 1890, chief petty officers stopped wearing a crown and anchor surrounded by laurel leaves on their left sleeves. Instead, they wore their branch badges upon their collars, while continuing to wear gilt buttons on their jackets and gold and silver embroidered cap badges (without the surrounding leaves). Chief petty officers did not wear good conduct badges.

This uniform is well illustrated by the chief petty officer from 1910 featured in Figure 53. His lapel badges show him to be a Chief Armourer (see Figure 47). The right-hand medal worn by this man is the Royal Navy Long Service Good Conduct Medal. One of the most common decorations found in photographs of Royal Navy employees, it was introduced in 1831 and rewards fifteen years of good service, with each wartime year counting as two years for the purpose of reckoning service longevity. Since 1848 it has had a distinctive blue ribbon with two outer thin white stripes, which usually shows up well in photographs.

53. Chief petty officer, 1910.

Engine Room Artificer

The engine room artificer, or 'ERA' role, was created in 1868 as a mechanic to work in the engine room, replacing the previous role of chief stoker. These men had to have civilian experience as an engine-fitter, boiler-maker or smith and sat an exam in order to enter the service. They were initially ranked as equivalent to petty officers or chief petty officers depending upon their seniority or 'class', but became warrant officers at the end of the nineteenth century.

A group of ERAs at leisure can be seen in Figure 6, but the uniform for an ERA was as depicted in Figure 54. Perhaps the distinguishing feature of this uniform is that the navy blue jacket and

54. Engine-room artificer, 1890s.

trousers allowed no particularly obvious marks of rank or qualification: no branch badges, good conduct badges or cuff stripes. The cap badge was the same as that worn by a petty officer except that the background to the anchor was purple cloth. The buttons on the ERA's jacket were gilded and there were two small additional buttons at the cuff, the same as a chief petty officer.

Military Officers

Commissioned military officers in the Royal Navy had adopted an official uniform by the end of the eighteenth century. Rank was demonstrated by several means, including the cap badge with surrounding gold leaves which was introduced in 1846 and which was initially confined to military officers (Figure 24). The stripes that encircle both cuffs are also important photographic clues to an officer's rank that are usually easy to see. The cuff stripes used in the Royal Navy from the early 1860s onwards can be seen in Figure 55. This 'distinction lace', as it was called, carried a loop or 'executive curl' in the uppermost stripe nearest the elbow, which was initially confined to military officers as a method of differentiating them from civil branch officers such as surgeons, engineers and so forth (see below).

Until 1861 a different system to that shown in Figure 55 prevailed for certain ranks, in which captains wore only three stripes (not four), and this cascaded down the officer ranks such that commanders wore two stripes and lieutenants one. Although the cuff stripes in Figure 55 were decided upon officially in 1861, this new method was not printed in *The Navy List* until 1863, leaving some doubt about how quickly or completely the new regulations were actually taken up before 1863. Suffice it to say that two possible methods of demonstrating rank with cuff stripes must be borne in mind when analysing photographs of captains, commanders and lieutenants from the early 1860s.

As with seamen, the Royal Navy laid down a series of uniform variations for its officers depending upon the circumstances. Collectively, these clothes proved extremely expensive for a new officer to buy. In 1891, for example, an officer had to provide himself with the following eight types of dress:

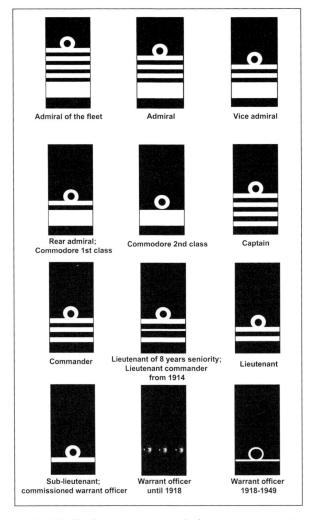

Admiral of the fleet Admiral Vice admiral

Rear admiral;
Commodore 1st class Commodore 2nd class Captain

Commander Lieutenant of 8 years seniority;
Lieutenant commander
from 1914 Lieutenant

Sub-lieutenant;
commissioned warrant officer Warrant officer
until 1918 Warrant officer
1918-1949

55. Cuff stripes for Royal Navy officers from about 1861 (or 1863) onwards.

1. 'Full dress', reserved for state occasions, receiving a sovereign or other ceremonial occasions of special honour.

2. 'Ball dress', for official or public balls, dinners and evening receptions.

3. 'Frock coat with epaulettes', when receiving royalty aboard ship, courts martial, funerals and ceremonies involving foreign officers.

4. 'Frock coat', worn for example for duties and ceremony ashore, for examinations, inspections and on Sundays.

5. 'Undress' uniform, the usual clothing for drill, exercises and everyday duties afloat.

6. 'Mess dress', for dinner, dances and entertainments on shore or in harbour.

7. 'Mess undress', for dinner at sea and with senior officers etc.

8. 'White undress', the white working uniform for hot climates.

Fortunately, when it comes to interpreting photographs, three of these uniforms alone tend to predominate: full dress, frock coat and undress.

Figure 56 shows various forms of the captain's uniform over a period of about eighty years. The image in the top left-hand corner shows a captain photographed in late 1860, bearing only three cuff stripes. All the other captains have four cuff stripes. This is the frock-coat dress of the period, and the characteristic full-length studio pose of the early 1860s. The frock coat is the commonest uniform for officers to be photographed wearing in the nineteenth century and although its length made it a somewhat impractical garment, it continued to be worn right up until 1939. In 1860, there was a change for military officers ranked commander and above. They had formerly sported plain gold ornamentation on the peaks of their caps, but in 1860 this changed to gold oak leaves, as seen here. This can be a helpful way to differentiate pre- and post-1860 photos of senior officers.

The captain photographed in 1890 at top right in Figure 56 appears in full dress uniform as laid down for ceremonial occasions. The distinctive elements of this included epaulettes, a cocked hat, a high gilded collar, a distinctive belt, sword, a stripe of gold lace down the outside seam of the trousers, medals worn in full and a distinctive cuff slash bearing three buttons at the end of the sleeve. This officer's four cuff stripes with executive curl denoting his rank of captain can be seen running underneath this slash. The full dress

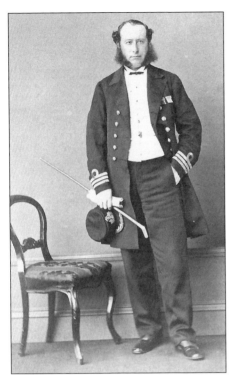
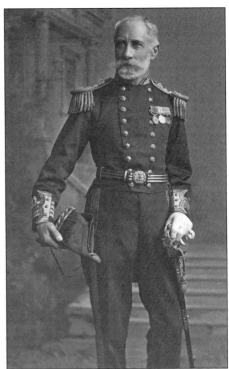
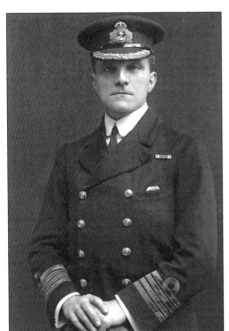
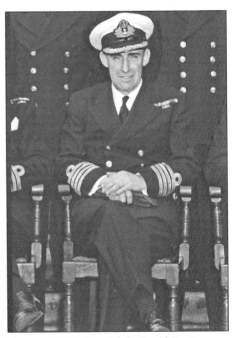

56. Four captains: c.1860 (top left); Basil Cochrane, c.1890 (top right); David Beatty, 1905 (bottom left); Captain Hart, 1942 (bottom right).

73

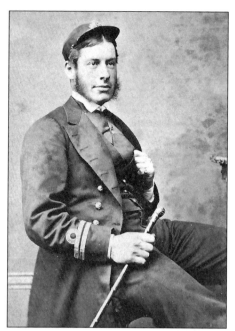
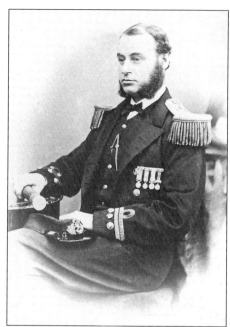

57. Four lieutenants: Lieutenant Phillimore, c.1865 (top left); c.1885 (top right); c.1900 (bottom left); senior Lieutenant Brian MacMahon, 1913 (bottom right) with inset of shoulder strap.

uniform was very expensive, but it was imposing and elegant so officers often wore this uniform for studio portraits.

The captain at bottom left wears the working 'undress' uniform of a captain in 1905. His double-breasted jacket has four pairs of buttons only, and ends just below the bottom of the photograph. Unlike the frock coat, it has a top pocket and a white handkerchief can be seen in it. This started as a male civilian fashion in the 1880s and had certainly reached the navy by the 1890s. The captain's uniform of 1905 is similar to the uniform of the late 1940s depicted at bottom right. Note that both captains have a single row of gold oak leaves on the peaks of their caps, and medals are worn as ribbons only. The white cap cover was removable and worn during summer time and in tropical conditions throughout the first half of the twentieth century.

Figure 57 shows how various versions of the lieutenant's uniform have appeared. Note that officers of this rank were not permitted to have gold on the peaks of their caps. The picture at top left shows a lieutenant in about 1865, with long frock coat and his two cuff stripes clearly visible. He wears a regulation waistcoat as well. His cap appears to be very small and tight-fitting, as was the style decreed in this era for all officers, which may explain why they are often photographed not wearing them. As the decades passed, caps became much fuller especially towards the end of the century.

At top right is a lieutenant from about 1885. He wears the uniform described in regulations as 'frock coat with epaulettes', and his cuffs demonstrate an important clue that may assist with dating photographs of commissioned officers of all ranks. Although he has the two cuff stripes of a lieutenant, he also wears three buttons running across the cuff as well. Cuff buttons have been used by the Royal Navy to denote rank since at least the eighteenth century. However, certain officers began to adopt them without official sanction *in addition* to their cuff stripes from about 1870, and in 1879 this was formally introduced into the regulations. Yet, this was only officially endorsed until 1891, when the cuff buttons were abolished and never seen again. This is thus a helpful dating clue for officers' photographs.

The lieutenant at bottom left wears the frock-coat version of the uniform as it appeared in about 1900. Note its length even at this date, which made it a most impractical and hot garment to work in. This uniform was required to be worn to examinations, and this young officer clutches a scroll of paper which might perhaps be his new commission as lieutenant after passing those examinations.

The lieutenant at bottom right wears the white tropical uniform for hot climates in 1913. The white uniform was introduced in 1885, and came with a helmet which was initially blue but soon changed to white. One version of the tropical helmet can be seen in Figure 94. Note that on this uniform, rank was designated on shoulder straps not on cuff stripes, as seen here. This convention was introduced in 1891. The man pictured was a lieutenant of at least eight years seniority because he has a thin gold stripe in between his two lieutenant's stripes. A close-up of the shoulder strap is shown for clarity. From 1914 onwards men wearing these stripes were re-designated as lieutenant commanders.

Propriety and tradition meant that officers were not allowed to expose their bare legs or arms on duty, even if it was very hot. A tropical uniform incorporating white shorts, and the option of a white short-sleeved shirt, was not introduced until 1938.

Figure 58 shows a flag officer in 1894. This rear admiral is standing on the deck of a ship; almost all shipboard photos date from the 1890s onwards. Note the double row of gold oak leaves on the peak of the rear admiral's cap to distinguish admirals and commodores (first class), from captains, commanders and commodores (second class) who each took only one row of oak leaves. Compare the rear admiral's cap to the caps worn by three of the captains in Figure 56 and the cap worn by the commander seen standing on the deck of a ship on the front cover of this book.

The officer to the right of the rear admiral in Figure 58 is his flag lieutenant. The lieutenant's rank is shown in the conventional manner by two cuff stripes, and his service on the staff of an admiral is shown by the braided gilt cord known as an aiguillette adorning his left shoulder. Other officers entitled to wear the aiguillette in this

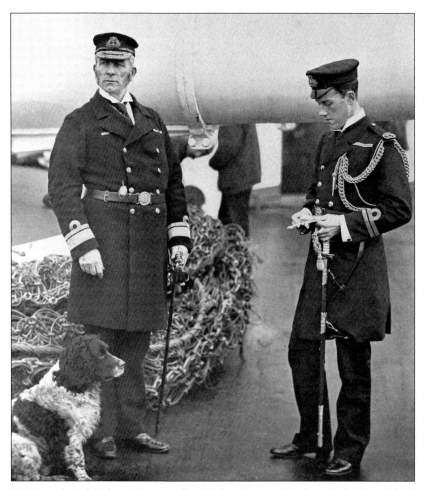

58. Rear admiral Arthur Alington (left) with flag lieutenant William Ruck-Keene, 1895.

way included captain of the fleet, flag captains and secretaries to flag officers and commodores.

Naval officers deployed ashore in the First World War wore army style khaki service dress and an example is shown in Figure 107.

Trainee Officers

Until the nineteenth century, 'young gentlemen' who wished to become Royal Navy officers needed to influence a senior officer who would pull strings to ensure they were taken on board as a midshipman. This was an on-the-job trainee role with limited responsibility. However, Victorian times saw the introduction of a

more formal and more open process of recruitment, and a stage of training was introduced prior to becoming a midshipman – that of the cadet. By the end of the nineteenth century, a cadet officer spent four years in academic and practical training ashore with around six months at sea before becoming eligible for the rank of midshipman.

The Navy had its own training establishments for cadets (e.g. at Dartmouth), but also took young men trained as cadets by other approved organisations – such as HMS *Conway* on the Mersey and the Thames Nautical Training College ('HMS *Worcester*'). A cadet from HMS *Conway* can be seen in Figure 27, while a Victorian Royal Navy cadet can be seen in Figure 59. Note the characteristic short

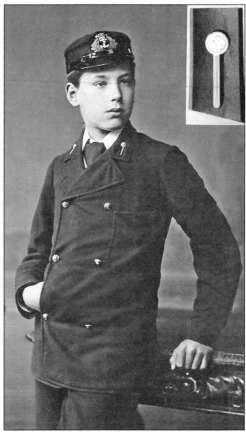

59. Royal Navy cadet officer, c.1880.

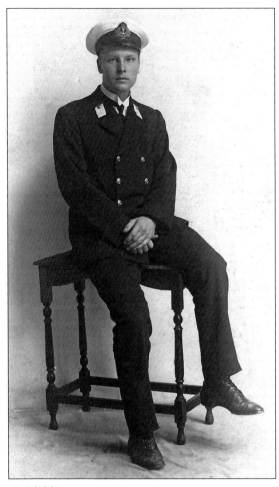

60. Midshipman, c.1910.

lengths of twisted white cord with a button on each collar. This 'twist and button' always indicates a cadet and was worn from the earliest Victorian times. Depending upon the style of jacket worn, the cadet was also permitted to wear three gold buttons running across the cuff.

Figure 60 shows a midshipman in about 1910. He has his officer's cap badge, but the most distinctive aspect of his uniform is the white

rectangular blocks of material at the collar known as 'turnbacks'. These were unique to Royal Navy midshipmen and usually make them easy to identify in photographs.

Civil Branch and Warrant Officers

One of the most complex areas of Royal Navy uniforms is the appearance of the various civilian and technical specialists employed by the navy as officers. These personnel did not necessarily possess any seagoing experience, but brought with them other skills and qualifications that the navy needed.

Some of these individuals were appointed directly from civilian life by Admiralty warrant as 'warrant officers'. These included carpenters and schoolmasters, for example. Other warrant officers were appointed by promoting chief petty officers who had acquired sufficient skill, and these included gunners.

Civil branch officers included surgeons, paymasters and secretaries, engineering officers and various instructors.

The navy deliberated over the relative status of all these specialists. How should they rank in relation to one another and in relation to commissioned military officers? How could they be distinguished from one another, and might they be allowed to wear the executive curl in their cuff stripes?

Warrant officers were initially denoted by three buttons running across the cuff (see Figure 55). The left-hand image in Figure 61 shows a warrant officer in 1900. A supplementary, thin, quarter-inch cuff stripe was awarded after ten years' service to wear in addition to the buttons, and the stripe was thickened to half an inch when a man became a chief warrant officer. This additional stripe had a curl in it for most warrant officers, but not carpenters.

The whole arrangement changed in 1918 when warrant officers were given a single quarter-inch stripe with executive curl but without supporting buttons. This appears as a very thin stripe in photos; it is seen in Figure 55 and in the right-hand image of Figure 61 which shows a warrant officer from 1946. If a warrant officer was commissioned, his cuff stripe consisted of a single, regular thickness (half-inch) stripe with a curl – the same stripe as a sub-lieutenant in Figure 55.

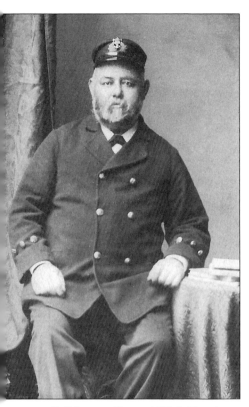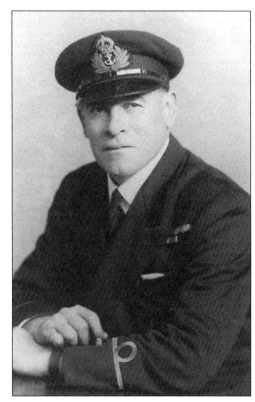

61. Warrant officer, c.1900 (left) and warrant officer, 1946 (right).

The navy invented a method to help differentiate some of its specialists at a glance – by inserting different coloured cloth in-between the cuff stripes to designate specialty. Starting in 1863, surgeons wore red between their stripes, paymasters wore white and engineers took purple. Later on, other colours were given to electrical officers, constructors, dentists and so on. Unfortunately, these colours are not useful when interpreting old black and white photographs, with the exception of the paymasters whose inserted white stripes are usually clearly visible, as Figure 62 shows. This is a photograph of a fleet paymaster in 1912. Note the plain gold band on the peak of this officer's cap; this was used from 1891 until 1918 to distinguish senior civil branch officers of the equivalent rank of commander and captain from their military branch counterparts. In the military branch, gold oak leaves were used on the peak instead (see Figure 56).

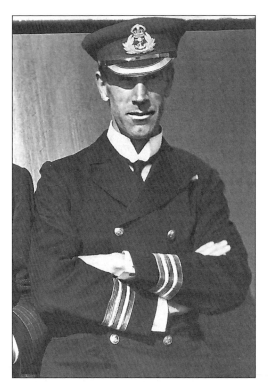
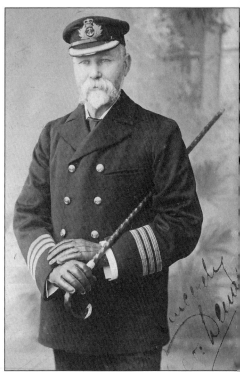

62. Fleet paymaster Richard Phillips, 1912 (left); fleet engineer John 'Theo' Denny, c.1895 (right).

Figure 62 also depicts a fleet engineer from the 1890s (right-hand image). The cloth between his three cuff stripes would have been purple, but of course this cannot be seen in this black and white picture. Yet, helpfully, his civil branch status is revealed by the plain gold band on the peak of his cap rather than oak leaves.

Although, colours may not be visible in black and white photographs, certain other dress regulations can help to identify a specialist's role in photographs. From 1860, for example, surgeons wore their uniform buttons in groups of threes, and this is illustrated in Figure 63: notice the six buttons in two groups of three. Similarly, the buttons worn by paymasters and secretaries were grouped into twos, while for engineers they were grouped into fours. All of these distinctive button arrangements were discarded in 1891.

Although photographs may not enable a man's exact role to be ascertained, it is useful to be aware that officers with cuff stripes without the executive curl before the First World War will be civil

branch officers rather than military. Engineering officers were permitted to take the executive curl in their cuff stripes from 1915 onwards, and surgeons, paymasters, secretaries and all other commissioned officers of the civil branches adopted the curl in their topmost cuff stripes in 1918. They each kept their distinctive colours between their stripes.

Note that all specialist and warrant officers were entitled to wear the full dress uniform when an occasion demanded it and Figure 64 shows an example of an engineer commander in 1908. Note the three plain stripes with no curl beneath the cuff slash. The material between these gold cuff stripes would have been coloured purple.

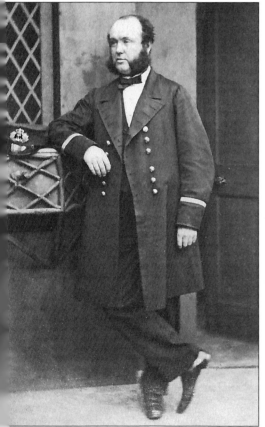

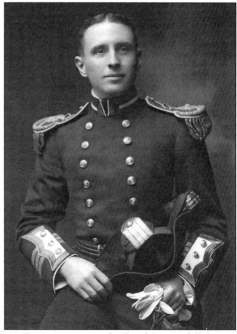

63. Assistant surgeon, 1860.

64. Engineer commander Frank Jose in full dress uniform, c.1910.

Facial Hair

Prior to 1869, the Royal Navy permitted bushy side whiskers (see Figures 57 and 63) but forbade the wearing of beards or moustaches. This was not always adhered to (Figure 51). After 1869, facial hair was officially allowed but men were not permitted to sport a moustache or goatee beard – it was a 'full set' of beard plus whiskers or nothing: 'Moustaches are not to be worn without the beard, nor is the beard to be worn without the moustaches'. These men had to keep their facial hair trimmed for the purposes of cleanliness, and commanding officers were exhorted to ensure that it looked neat and professional.

Needless to say, these stipulations were sometimes ignored and there are photographs demonstrating a flouting of the official requirement – most particularly naval men with moustaches. Sometimes this might be explained by men on extended leave quickly growing a moustache before having a photograph taken; some civilians with a moustache might also have chosen to dress up as a sailor before having their photograph taken. However, it's also clear that some serving men do seem to have got away with non-regulation facial hair, at least for long enough to be captured on camera, although this is rare after the First World War.

'Non-regulation' facial hair was particularly common among reservists who were based ashore or who served on small coastal craft rather than on warships. Here, a greater degree of latitude was accepted and these men are quite commonly photographed wearing moustaches. It is reasonable to suppose that the man with the big, bushy moustache photographed in Figure 10 might be a reservist, for example. Reservists mobilised into the theatre of war where they might engage the enemy were expected to conform to Royal Navy facial hair regulations.

The Monarch's Crown

The shape of the crown on cap badges and other badges worn by Royal Navy personnel has changed somewhat with the monarch, and can be used to help date photographs. During the reign of Victoria, the crown was rather low and flattish compared to later versions (e.g. look at Figures 49, 51, 54, 58, 59 and 89). This means that it is not always very prominent on the cap badge. During the

reign of Edward VII, George V and George VI the crown was more upright and blockish (e.g. Figures 53, 84, 85, 87, 91, 92, 95, 98 and 99). Figure 62 is a particularly helpful illustration for comparing the shape of Victoria's crown (right) with that of her male successors (left). Since the ascent of Elizabeth II in 1952 the crown has been more bulbous (Figure 24).

Example Records for Royal Navy Ancestors

Royal Navy personnel records are very extensive and varied. They are mostly held at TNA and its website has a wide range of research guides to assist you, www.nationalarchives.gov.uk. Given the great diversity of resources available, only a small number of example sources can be listed here:

• Many officers' service records at TNA are in series ADM 196 (1756–1917) and ADM 340 (1880–1950s). Ratings' records are held in ADM 139 and ADM 188 (1853–1923). Put an ancestor's name into the *advanced search* in TNA's Discovery facility at http://discovery.nationalarchives.gov.uk/ and use the 'Search For Or Within References' feature to restrict your investigation to one of these ADM series.

• Registers documenting officers' and ratings' pensionable navy service from 1802–1919 (ADM 29 at TNA) can be searched via www.ancestry.co.uk.

• *The Navy List* was published regularly throughout the year and records the postings of officers. There are many free copies online (e.g. http://books.google.co.uk) and on subscription sites (e.g. www.ancestry.co.uk).

• Royal Navy personnel who died in either world war are listed on the Commonwealth War Graves Commission website at www.cwgc.org.

• For comprehensive records after about 1920, next of kin must apply to the British government: type 'military service records' into the website http://www.gov.uk for more details.

• The National Museum of the Royal Navy does not have service records, but has a library that may assist you in other respects, www.nmrn-portsmouth.org.uk/collections.

Chapter 4

SERVICES LINKED TO THE ROYAL NAVY

In addition to the seamen, specialists and officers described in the previous chapter there have been a number of services affiliated to or a part of the Royal Navy, each with its own distinct uniforms, and some of these are discussed here. They include the Royal Marines, Women's Royal Naval Service, Queen Alexandra Royal Naval Nursing Service, Royal Naval Air Service, Royal Naval Transport Service and Royal Fleet Auxiliary. Note that the many and varied naval reservist services are considered separately in Chapter 5.

Royal Marines
The history of the uniform of the Royal Marines is particularly complex, and a book of this size can do no more than scratch the surface of the subject. I have included some example photographs to illustrate the range of appearance, and to hopefully spark recognition of a potential Royal Marine ancestor that should prompt further investigation.

A particularly helpful publication which contains many photographs of Royal Marines' uniforms is *Personal Distinctions – 350 Years of Royal Marines Uniforms and Insignia* (John Rawlinson, Royal Marines Historical Society special publication no. 41, 2014).

On land, the marines were mainly based at Portsmouth, Plymouth and Chatham, so many photographs of them were taken in or near these three locations.

Privates and Non-Commissioned Officers
When photography started to become popular in the 1860s, there were two types of marine. The Royal Marines Light Infantry (RMLI)

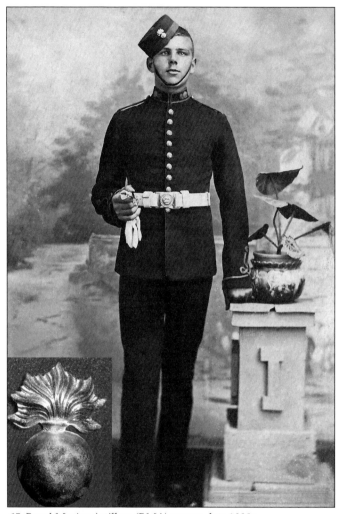

65. Royal Marine Artillery (RMA) gunner, late 1890s.

were soldiers deployed from and on board ships; their artillery counterparts responsible for heavier weaponry were the Royal Marines Artillery (RMA). They were known as the red marines and the blue marines respectively, because of the colour of their uniforms. There were far more men serving with RMLI than RMA.

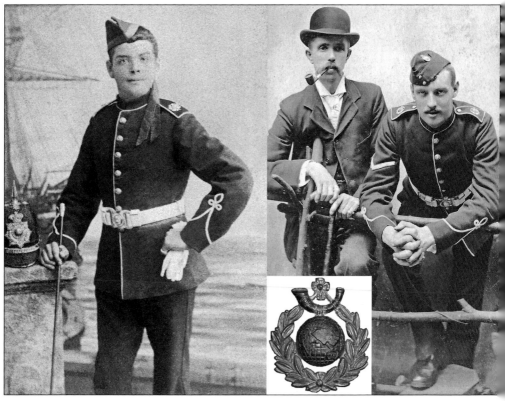

66. RMLI private, 1880s (left) and a lance corporal, c.1898 (right).

Figure 65 shows an RMA gunner in the late 1890s. Note the distinctive 'pill box' cap which had a thick yellow band around the bottom, and it bears a metal badge depicting an exploding grenade. This basic design was used from the 1860s until 1903. The grenade badge is shown in more detail in an inset to the photograph. An embroidered version of this emblem is also repeated on both sides of the collar. The dark tunic-like jacket emphasises the characteristic thick white belt and the looping braid on the cuffs. The central buckle bears the name of the marines' most famous victory, and the corps' motto 'Gibraltar – *per mare per terram* [by sea by land]'.

Non-commissioned officer ranks in the RMA were lance

bombardier, bombardier and sergeant – depicted by one, two and three v-shaped stripes on the right arm (see Figure 68). The commensurate number of miniature metal stripes could also be affixed below the grenade on the cap badge.

The rank and file enlisted man in the RMA was known as a gunner (Figure 65), but in the RMLI he was known as a private, and an example of a RMLI private is seen in the left-hand image of Figure 66. Dating from the 1880s, the private wears what was called the Glengarry cap – with its long tails hanging over his shoulder – which was introduced in 1870. There was a metal 'globe and laurel' badge on the left-hand side which cannot be seen here. Observe the ship in the background painted on a screen in the photographer's studio but attesting to the marines' maritime role. Notice also this man's spiked cloth helmet on a pedestal which was first worn in 1878. The brass plate on the helmet depicts a large star with a globe at the centre, and it is topped with a crown. Men serving with the RMA wore this helmet as well but the helmet plate was round with flames emanating from the top: similar to a larger version of the exploding grenade badge in Figure 65. The spike atop the RMLI helmet was also replaced by a ball in the RMA.

The right-hand image in Figure 66 is from about 1898 and shows the field or forage cap worn by both RMA and RMLI. Unlike the Glengarry cap, this field cap – which came into being in 1897 – had two buttons at the front and no 'tails'. In Figure 66 it carries the 'globe and laurel' cap badge of the RMLI consisting of a map of the eastern hemisphere surrounded by leaves. There were many different versions of the globe and laurel: this one was surmounted by a bugle and it is shown enlarged in the inset. An embroidered globe and laurel design is found on each shoulder strap in both images in Figure 66. The distinctive elongated braid at the cuffs is of a design known as the trefoil pattern which was adopted by the RMLI.

Apart from the caps, note the overall similar appearance of the uniforms in Figures 65 and 66 in these black and white photographs: neat tunic-like jacket, broad white belt, the looped braid on the cuffs and shoulder straps.

A notable feature of the uniform worn by the man on the right in

Figure 66 is that the wearer has a single v-shaped stripe on his right arm only. This arm was used to designate rank among non-commissioned officers, and in the RMLI a single stripe indicated a lance corporal. Two stripes was a corporal and three a sergeant.

Figure 67 is another image of a man serving with the RMLI, but a later picture taken in about 1905. This photograph was over-painted by the photographer to bring out the colours of the uniform

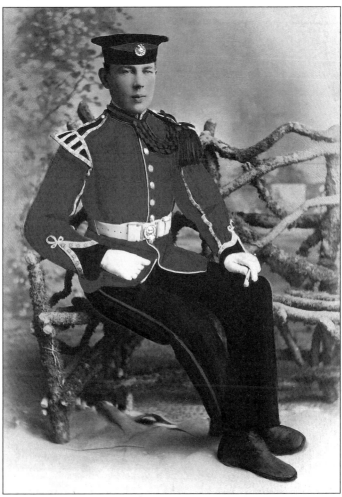

67. RMLI drummer Charles Taylor, c.1905.

– the red jacket, red stripe down the side of the trousers, red flash on the cap and so forth. The close-fitting tunic-like jacket is still in evidence, with its white belt, shoulder straps and trefoil pattern embroidery at the cuffs. Yet, note the more modern style 'Broderick' cap which was adopted by both RMA and RMLI to replace the field cap in 1903. It bears the RMLI globe and laurel cap badge prominently at the front, rather than on the side as on the field cap in Figure 66. The cord and tassels draped over his left shoulder show that he was a musician, reminding us of the marines' long association with bands and music. The raised white-striped shoulder features (known as 'wings') were worn to indicate that the individual was either a bugler or a drummer, but closer examination shows that this man is clutching a drumstick in his left hand.

In the First World War, some marines fought on land and wore khaki service dress; both images in Figure 68 demonstrate this. The left-hand picture shows a sergeant in the RMA, as evidenced by the

68. First World War marines fighting on land: sergeant in the RMA (left) and private in the RMLI (right).

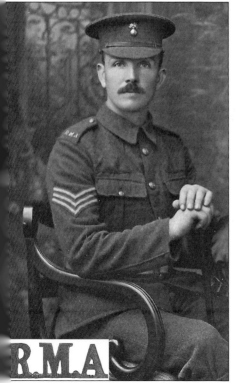
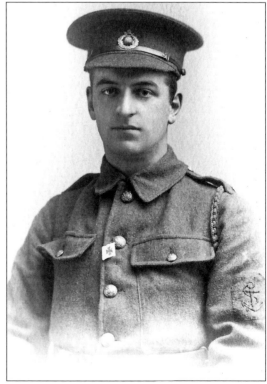

three stripes on his right arm. Note that the RMA exploding grenade emblem has been retained as his cap badge. It is not easy to see without a lens in this photograph, but both shoulder straps also carry the metal letters 'RMA', as shown enlarged in the inset.

The right-hand image in Figure 68 is a private in the RMLI serving with the Royal Naval Division in 1916. He again wears the khaki uniform, but note the globe and laurel on his cap badge. Despite his deployment on land and his army like uniform, he wears the fouled anchor of the Royal Navy on his left arm, attesting to his service origins and the cord over his left shoulder is a lanyard. Compare this image to Figure 106, which shows a leading seaman in the Royal Naval Division, and the similarities are obvious.

Figure 69 illustrates the white tropical dress of non-commissioned officers worn as a lighter alternative during hot conditions. It is quite commonly seen in photographs, this image dating from 1916.

69. RMLI sergeants in tropical dress, 1916. The officer in khaki is a lieutenant.

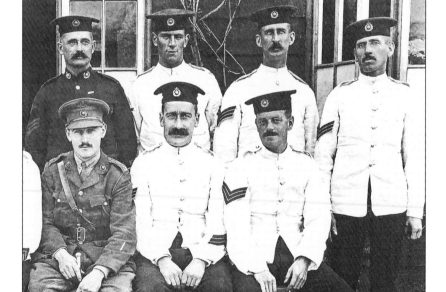

In Figure 69, the marines are sergeants with the RMLI (notice globe and laurel cap badge), assembled with an officer. The status of sergeant is shown by all of them having three stripes on their right arms, including the sergeant in regular uniform at top left. Note the relative informality of the image which is quite common in non-studio photographs of marines – not all of the sergeants wear the same version of their uniform; the sergeant sitting right is smoking a cigarette. With them is a RMLI officer in khaki, discussed in more detail below.

Many of the men in Figure 69 sport moustaches. Marines were officially exempt from Royal Navy regulations concerning facial hair (Chapter 3) and the moustache was not only permitted but was, in fact, very common.

In practice, RMA and RMLI marines operated side by side on board ship and had overlapping duties. Hence they are often pictured together in photographs taken on board ship. Figure 70 shows an example of this taken in the First World War; this is the typical shipboard appearance of marines during this period. The picture shows a group of privates in the RMLI, plus a colleague from the RMA (back row, left). Pictures of this kind, where RMA and RMLI are photographed together, usually indicate that they were serving on a large battleship since RMA men were only deployed on bigger vessels. On smaller ships, the marines complement was RMLI alone.

All of the men wear a blue uniform with blue Broderick cap. The RMLI privates have their globe and laurel cap badge with bugle above, which they also carry on each side of their collar; the RMA gunner has his grenade cap badge. Yet, otherwise these marines have identical uniforms: caps, white belt, shoulder straps, arrangement of buttons. The white upper part of each man's cap was a removable cover that was generally worn in warmer weather, as ordered. A RMLI private from this era without this white cap cover can be seen in Figure 9.

In 1923, the RMLI and RMA were joined into a single force now known as the Royal Marines, and the globe and laurel was chosen as the emblem to represent them. Rank and file men known

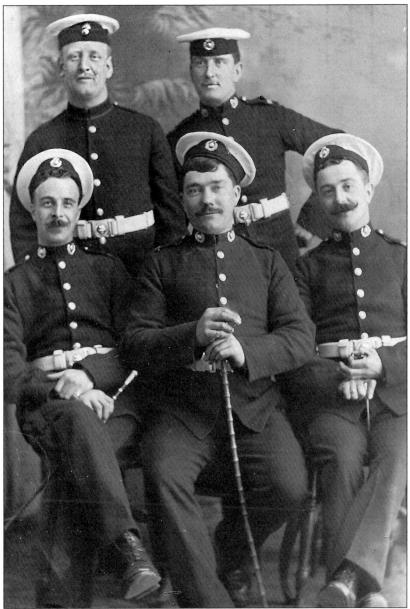

70. Privates in the RMLI on board ship in the First World War. A colleague from the RMA can be seen back row, left.

previously as privates (RMLI) or gunners (RMA) were now all known as marines. Figure 71 shows a marine from about 1938 in full dress uniform; the globe and laurel can be clearly seen on his cap. To indicate their connection with the sea and help distinguish them from the army, marines wore the so-called 'slashed cuff' at both sleeves, reminiscent of the dress uniform for Royal Navy officers, and this is clearly seen here. This universally carried three gold buttons, the number of buttons not being an indication of rank. However, this marine does have three large inverted chevrons on his *left* sleeve. These were good conduct badges used to indicate years of continuous good service, but these were not awarded according to the system adopted for Royal Navy ratings (see Chapter 3). In the marines, the first badge was awarded for two years' service, the

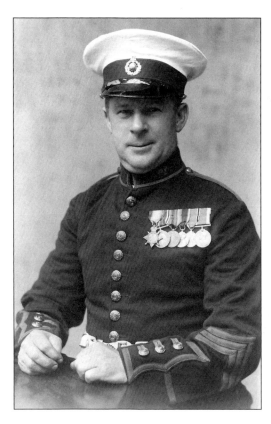

71. Marine in full dress uniform, 1938.

second for six years, three chevrons for twelve years (as seen in this photograph), four for eighteen years, five for twenty-three years and six for twenty-eight years. The marine in Figure 71 has thus served between twelve and eighteen years with good conduct.

The Royal Naval School of Music was created in 1903, and served to train musicians for the Royal Marine bands that existed on ships and ashore. This organisation developed its own distinct uniforms, and the marine in Figure 72 is an example. He is a musician and displays a characteristic metal lyre on both collars; he also has a miniature lyre above his globe and laurel cap badge (enlarged in the inset to the picture).

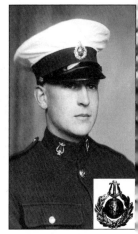

72. *Royal Marines musician Walter Carey, 1930s.*

Officers

Commissioned officer ranks in the marines followed the army pattern: second lieutenant, lieutenant, captain, major, lieutenant colonel, colonel, brigadier, major general, lieutenant general, general. Ranks were indicated in different ways according to uniform type and era but can, for example, be identified by the markings on shoulder straps. Unfortunately, these are not always easy to see clearly in photographs. One star on a shoulder strap indicated a second lieutenant, two for a lieutenant and three for a captain; a crown by itself denoted a major, a crown with a star a lieutenant colonel, a crown with two stars a colonel and so on.

It is not possible to show more than a few examples of officers' uniforms here to illustrate the diversity of appearance across a period of nearly a hundred years.

Figure 73 is a photograph of a RMA lieutenant in undress uniform in the 1860s. He wears the officer's version of the rounded 'pill box' cap seen in Figure 65, the sides of which carried a broad band of patterned gold material that often looks white in photographs where it catches the sun or the camera's flash. Only officers wore the looping braid across the chest of their jackets (known as 'frogging').

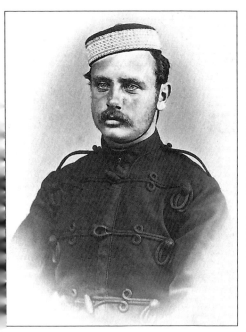

73. RMA Lieutenant Francis Poore in undress uniform, c.1865.

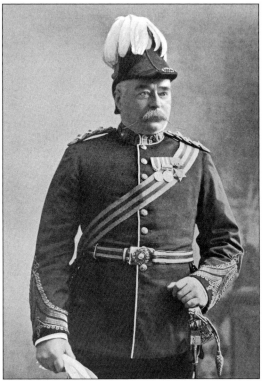

74. Colonel John Morris of the RMLI in full dress uniform, 1899.

Yet this officer wears no insignia of his rank. In fact, dressed like this, he is not distinguishable from a Royal Artillery officer of the same period, which is important to bear in mind if analysing photos of this kind. You 'army officer' ancestor might actually have been a marine or vice versa.

A far more imposing figure is the RMLI colonel in full dress uniform from the late 1890s, as seen in Figure 74. The plume of feathers on his black bicorn hat were white with red ones underneath. The sash had gold and crimson stripes, and the ornate embroidery at the cuffs was also gold against the bright scarlet tunic. Note that his belt was different to the RMLI private's plain white one, having two gold stripes, but the colonel still sports the globe and laurel emblem on both collars. His trousers were blue.

A lieutenant in the RMLI from 1909 is depicted in Figure 75. His uniform jacket was bright red with trousers carrying a thin red line down their length. The rank of lieutenant is indicated by two silver

star-shaped studs on his woven gold-braid shoulder straps. He sports the globe and laurel emblem at his collar, and carries the white helmet with gold ball-shaped pommel that was worn by both RMLI and RMA. The golden star-shaped plate on the helmet incorporated a globe and the motto of the marines.

Figure 69 shows a RMLI officer in khaki, deployed on land during the First World War. His globe and laurel cap badge is also repeated

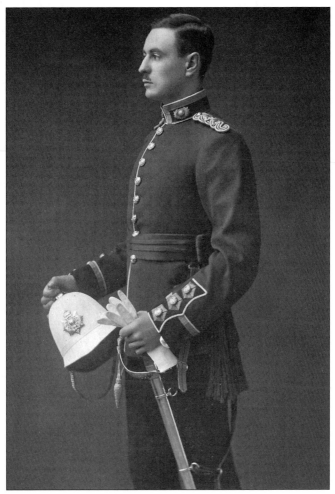

75. RMLI lieutenant, 1909.

on both lapels and was made of bronze so it does not show up so well on photographs. The two stars on his shoulder straps reveal he is a lieutenant. Note the thin, bright metallic strip on his left forearm – this is a wound stripe indicating a significant injury during battle. These were introduced in 1916 and not worn after 1922. Royal Marines could also wear war service chevrons (see Figure 48 and associated discussion in the text).

Figure 76 illustrates an officer in a Royal Marines blue beret from the 1940s. The blue beret was introduced in 1943 and was worn by officers and marines attached to a ship and on sea service. This beret is therefore not an indication that wearers were trained as commandos. The globe and laurel was

76. Second lieutenant in service dress, c.1945.

worn on a red patch on the beret, always on the left side – a small separate emblem of a lion standing on a crown was placed above it. This was added to the globe and laurel cap badge in 1923 to signify the 'royal' status of the corps. In Figure 76 the globe and laurel can also be seen on both lapels in bronze. This officer is a second lieutenant as he has only one bronze star on his shoulder strap. This star is visible at the far left-hand end of the officer's left shoulder strap, and is followed by the letters 'RM' which are just discernible at the margin of the image.

Finally, Figure 77 illustrates a major in the Royal Marines from about 1945. The rank of major is denoted by the single crown on each shoulder

77. Royal Marines major, c.1945.

strap; note the accompanying metal 'RM' badge. He carries the globe and laurel emblem on his collars, as well as on the face of his cap where the lion standing on a crown is once more present. This is a field officer's forage cap and it has a single row of gold leaves on its peak.

Example Records for Royal Marine Ancestors

TNA holds many career details. Look at its online research guides at www.nationalarchives.gov.uk (indexed under 'R' for Royal Marines). For example, the service records for officers commissioned between 1793 and 1925 are available online among Royal Navy officers' papers (series ADM 196). Service records for non-officer ranks for the period 1842–1925 are in ADM 159, as well as attestation records (1790–1925), which often give more personal information, in ADM 157. Put an ancestor's name into the *advanced search* in TNA's Discovery facility at http://discovery.nationalarchives.gov.uk/ and use the 'Search For Or Within References' feature to restrict your investigation to one of the ADM series identified above. For records after 1925, next of kin must apply to the British government: type 'military service records' into the website at http://www.gov.uk for more details.

The Royal Marines Museum also has a valuable archive at www.royalmarinesmuseum.co.uk and officers are also listed in the regularly published *The Navy List*.

Women's Royal Naval Service

The Women's Royal Naval Service (WRNS) was created in 1917, enlisting women to carry out shore-based functions that would otherwise have been undertaken by men in the Royal Navy. The intention was to free up these men so that they could go to sea. It had been envisaged that women's responsibilities would be largely domestic ones such as catering, but in fact they were to fill a wide variety of positions such as clerical, technical and administrative roles. The initial letters of the WRNS inevitably led to its personnel becoming known as 'wrens'. By the time the service was wound up in 1919, around 7,000 women had been recruited over the 19 months of its existence. Some had even served abroad.

The proven value of the WRNS meant that it was immediately reconstituted at the beginning of the Second World War. In 1944, the service consisted of over 74,000 women who performed over 200 different duties including roles in training, maintenance, mechanics, communications, ordnance, meteorology, archives, supplies, mail, radar and research. The WRNS was established as a permanent service in 1949, but remained separate to the Royal Navy until 1993.

Uniform

The WRNS uniform in the First World War was regarded as rather frumpy and unattractive at the time, and it's easy to see why. WRNS ratings wore a rather shapeless, sack-like frock, which buttoned high up, with a broad belt. The 'sailor's collar' with its three white lines worn by many WRNS ratings was not originally sanctioned, so ratings often borrowed the collar of their male counterparts or even made their own to bestow a more nautical appearance. An example is seen in Figure 78, where two WRNS ratings sit either side of a civilian. One of the ratings, distinctly unimpressed by her uniform, sent this photo to a friend and wrote on the back 'please don't laugh at me Elsie'. The gabardine hat was curiously pudding-shaped, but as can be seen by comparing it with the civilian in the same photograph, it was based upon prevailing female fashions in headwear.

78. Two First World War wrens with a civilian friend.

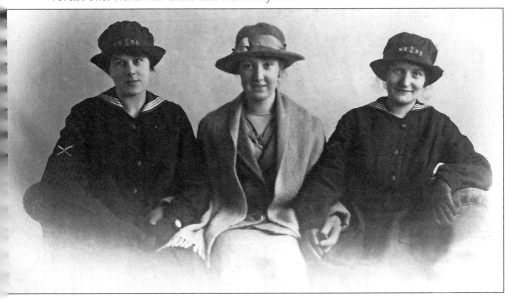

In the First World War, the cap tally carried the text 'WRNS' with a crown-topped anchor in between the 'R' and the 'N'; in the Second World War the tally usually bears a simple 'HMS' or the name of the establishment at which the rating was based (see Figures 79 and 80). Caps and hats in both world wars could accommodate a white cover worn over the crown, as used in the Royal Navy, and as seen in Figure 80.

Any branch badges worn on the right arm had to be pale blue to distinguish them from the versions used by men in the Royal Navy. The wrens in this picture both have a badge showing two crossed quill pens – it can be seen more clearly on the arm of the wren on the left. This was the symbol of the clerical branch in the First World War. The WRNS developed many badges of their own: a steering wheel emblem was used to denote drivers, for example; crossed keys for storekeepers, porters and messengers; and a shell to indicate the household branch that undertook a variety of domestic duties, and so on. For many wrens, the official uniform was worn only for formal occasions, especially if their role was likely to make a uniform dirty (e.g. catering, cleaning, manufacturing). In these situations, apparel more suitable to the individual's role was donned for day-to-day working. Bell-bottomed trousers could be worn for very active work.

The WRNS adopted the double-crossed anchor which the Royal Navy used to denote its petty officers (see Figure 52). In the First World War women with this rank were called 'section leaders', and in the Second World War they were termed 'petty officer wrens'. Again, this badge was blue, and an example from about 1940 can be seen in Figure 79. The three wrens in this image are dressed in formal jackets with collars and ties, but the petty officer is the central figure. Unlike the two other wrens pictured, she was allowed gilded buttons, a tricorn hat with a crown and anchor badge, and she bears the petty officer crossed anchors on her left upper arm.

The WRNS wore a blue fouled anchor ('killick') on the left arm to indicate the equivalent of the Royal Navy's leading seaman. This rank was denoted as 'leader' in the First World War and leading wren in the Second World War. The wrens sitting either side of the section leader in Figure 79 have the killick attesting this role. On their right

arms, both leading wrens have a star which was a branch badge indicating a range of functions for which a specific badge was not available.

In Figure 79, dating from the beginning of the Second World War, the leading wrens still wear a version of the 'pudding bowl' hat. However, in 1942 female ratings were allowed to wear the Royal Navy rating's cap for the first time and this is seen in Figure 80. The jacket worn here was blue, the blouse white and the tie black. Ratings and petty officers in the Second World War earned good conduct chevrons in the same way as their Royal Navy colleagues, and many branch badges used by the Royal Navy and WRNS were the same in the Second World War although WRNS developed some unique to its service (e.g. a telephone symbol for a switchboard operator).

Wrens attached to the Royal Marines were known as 'Marens' and wore the globe and laurel cap badge of the Royal Marines (see above) with a red patch behind it.

79. A petty officer wren (centre) flanked by two leading wrens, c.1939.

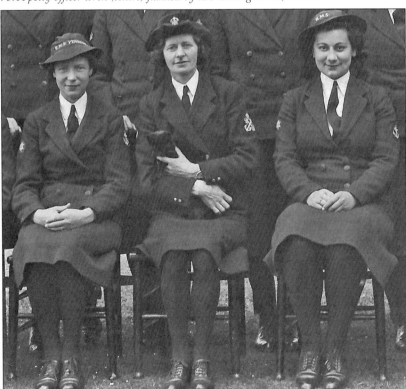

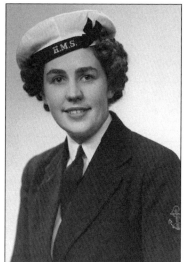

80. A leading wren, 1942.

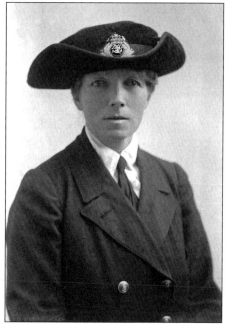

81. An officer in the WRNS, First World War.

WRNS officers looked very different to their male counterparts in the Royal Navy. In the First World War perhaps the most notable feature was their overly large tricorn hats. Female officers wore the Royal Navy commissioned officer's cap badge but with the leaves surrounding the anchor in blue rather than gold and the letters 'WRNS' were interposed between the crown and the anchor. The the First World War officer's hat and cap badge can be seen in Figure 81.

WRNS officer rank was usually indicated by cuff stripes bearing a diamond set on top of the uppermost stripe, although in the First World War some WRNS officers known as 'principals' bore stripes only with no diamond. The stripes had again to be blue and not gold. The uniform was completed by a jacket, very long plain skirt reaching to the ankles, a high-collared white blouse with a plain black tie and black stockings and shoes.

Women officers did not use the same titles as their male equivalents. The most senior WRNS officer rank was director in the First World War, but the honorary position of commandant was established above this in the Second World War and was held by a member of the royal family. Below this came a series of ranks that varied slightly according to the era, but the structure in 1945 was: commandant, director, superintendent, chief officer, first officer, second officer, third officer. Examples of how these ranks were designated using cuff stripes can be seen in Figure 82, with each image dating from 1943. The 'WRNS' lettering on officer cap badges was dropped for the Second World War, and the enormous tricorn hats worn by WRNS officers in the First World War were replaced by neater, smaller versions.

Figure 83 shows two wren officers seated either side of a nursing sister in 1942. The officer to the left is a first officer, with one thin cuff stripe in between two broader stripes; the woman seated to the

82. Senior officers in the WRNS, 1943: commandant/director (left), superintendent (middle) and chief officer (right).

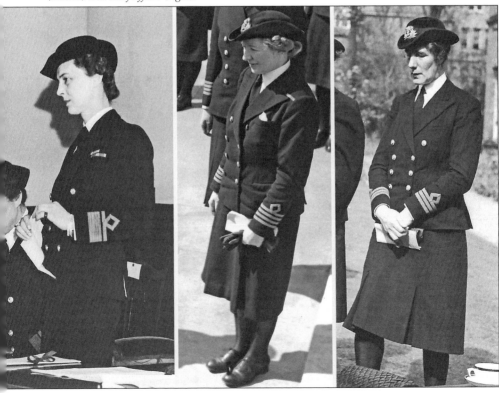

right, with two cuff stripes, is a second officer. A third officer at this time (not illustrated) carried one stripe. Note in this photograph and Figure 82 that skirts were not ankle-length as in the First World War, but still came to below the knee. In the Second World War the skirts were also pleated.

There was an all-white form of the WRNS uniform after 1939 which was worn in hot climates abroad. WRNS personnel served in Singapore, Sri Lanka, Egypt and South Africa, for example.

Example Records for WRNS Ancestors

First World War service records are held at TNA and there is an online research guide on this subject at www.nationalarchives.gov.uk (look under 'R' for Royal Navy personnel). For example, WRNS officer career records for the First World War are available online (ADM 318 and ADM 340), as well as records for ratings (ADM 336). Put an ancestor's name into the *advanced search* in TNA's Discovery facility http://discovery. nationalarchives.gov.uk/ and use the 'Search For Or Within References' feature to restrict your investigation to one of these ADM series. For records after 1938, next of kin must apply to the British government: type 'military service records' into the website http://www.gov.uk for more details.

The National Museum of the Royal Navy has a unique historic collection related to WRNS, see www.nmrn-portsmouth.org.uk/ collections.

Queen Alexandra Royal Naval Nursing Service

The Queen Alexandra Royal Naval Nursing Service (QARNNS) was established formally in 1902 to work in Royal Navy hospitals, and the name derives from Queen Alexandra's personal interest in establishing the organisation and then becoming its patron. Until the 1960s all QARNNS nurses were women. Yet in their hospital duties, QARNNS personnel could be assisted by male sick-berth attendants when not needed at sea (e.g. see Figure 101) and in wartime by Volunteer Aid Department (VAD) nurses.

A distinctive feature of the uniform of senior personnel was an elongated badge worn on the right-hand side of the cape of

QARNNS sisters and matrons. The *detail* of the badge is usually difficult to see in all but the most high-resolution images, but the basic design consisted of a crown above two letter 'A's superimposed upon an anchor, and below this was a red cross within a circle. However, the black background to the badge and its distinctive shape often makes it stand out in even the poorest quality images. Figure 83 shows a QARNNS sister flanked by two wren officers in 1942 and the cape badge can be clearly seen; the inset shows a close-up of one version of the cape badge.

Example Records for QARNNS Ancestors

TNA holds some career details. Look at its online research guide at www.nationalarchives.gov.uk (indexed under 'N' for Nurses, then choose Royal Navy). For example, QARNNS service records (1894–

83. A QARNNS sister (centre), 1942. The inset is a close-up of her cape badge. The WRNS personnel are a first officer (left) and second officer (right).

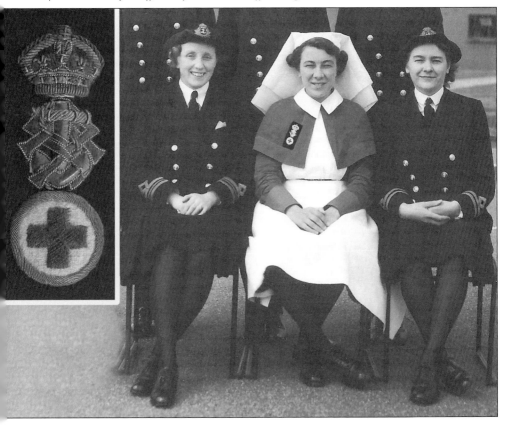

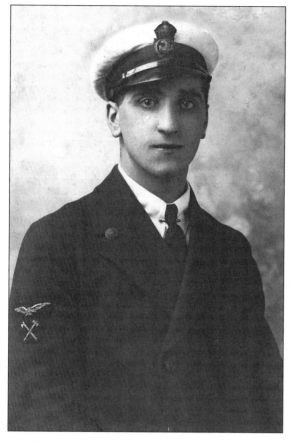

84. An artificer with the RNAS, 1917.

1929) are available in series ADM 104. These large files are indexed online by year only but they can be downloaded for free to search at home. For records after 1929, next of kin must apply to the British government: type 'military service records' into the website http://www.gov.uk for more details.

Royal Naval Air Service and Fleet Air Arm

The Royal Naval Air Service (RNAS) was officially created in 1914 as an air force that operated under the direction of the Admiralty, but in 1918 it merged with the Royal Flying Corps to form an independent Royal Air Force (RAF).

The personnel of the RNAS used largely the same uniform as the Royal Navy, except that a flying eagle emblem was incorporated into it in various ways. For example, Figure 84 shows a rating in 1917. They often wore the uniform of men not dressed as seamen (compare to Figure 49). He has the same basic cap, cap badge and uniform as an Royal Navy rating, yet the branch badge on his right arm of a crossed axe and hammer (indicating artificer) has an eagle in flight over the top of it. A particularly common branch badge consisted of a two-bladed propeller, which was worn by engineers. The same badge was used by air mechanics in the Fleet Air Arm (FAA) from 1939. The letters 'AAC' on the right sleeve indicated the Anti-Aircraft Corps; the letters 'RNAS' was sometimes embroidered on the shoulders of coats.

Petty officers in RNAS still used the two crossed anchor design as per colleagues in the Royal Navy (see Figure 52), but the anchor on their cap badges and buttons was replaced by the flying eagle.

Officers that joined the RNAS directly wore a cap badge distinctive to the service. The commissioned officer badge of the Royal Navy was adapted so that the fouled anchor sitting below the crown was replaced by the flying eagle design. Figure 85 illustrates this. The eagle was also borne above the left-hand cuff stripes worn by flying officers, but these were otherwise the same design as those worn by commissioned officers in

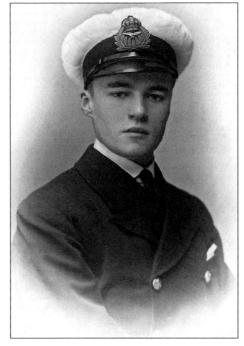

85. An RNAS commissioned officer, First World War.

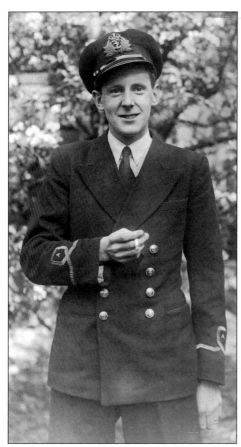

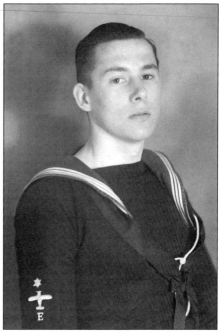

86. A sub-lieutenant with the air branch of the RNVR, Second World War (left) and naval airman mechanic (engines), 1949 (right).

the Royal Navy proper, complete with a curl in the uppermost stripe (see Figure 55). From 1917, the eagle was worn on both cuffs. Ranks ranged from the four-striped wing captain, to wing commander, squadron commander, flight lieutenant and flight sub-lieutenant. Marines in the RNAS could also sport the eagle on their cuffs, but from 1916 they could wear a large embroidered eagle on their left breast if a flying officer.

There were also observer officers in the RNAS who were not pilots and whose flying eagle emblem incorporated a letter 'O' to replace the eagle's head.

The FAA was formed in 1924. Ratings in this service wore a variety of specially designed branch badges on their right arms, or on their collars if a chief petty officer. These included aeroplane designs, and two- or four-bladed aeroplane propellers. For example, the right-hand image in Figure 86 shows a naval mechanic who

worked on plane engines, as shown by the letter 'E' below his plane branch badge.

From 1939, officers in the FAA who were not trained as seagoing military officers were obliged to wear a letter 'A' inside the curl on both cuff stripes. This was accompanied by a winged anchor surmounted by a crown, worn above the curl on the left sleeve if these men were pilots. This 'A' was not confined to aircrew but included officers who were part of air traffic control, air engineers and so forth. During the Second World War, most Royal Naval Volunteer Reserve officers serving in the FAA were also designated as air branch officers and wore the 'A'. Figure 86 shows a sub-lieutenant with the RNVR air branch in the Second World War.

Example Records for RNAS and FAA Ancestors
Consult the research guides to both services on TNA's website, www.nationalarchives.gov.uk. The Fleet Air Arm Museum archives also hold some records related to each service, http:// www.fleetairarm.com/ naval-aviation-research.aspx.

TNA holds RNAS officers' service records in series ADM 273, and RNAS ratings were included with Royal Navy ratings in ADM 188. Put an ancestor's name into the *advanced search* of TNA's Discovery facility at http://discovery.nationalarchives.gov.uk/ and use the 'Search For Or Within References' feature to restrict your investigation to one of these series.

After 1918 you should explore RAF documents as well, since RNAS records for active personnel were transferred over to this service.

Royal Naval Transport Service
The Royal Naval Transport Service (RNTS) was created in 1916 and continued until about 1919. Its officers were responsible for logistics – supervising and enabling the loading and transport of troops, stores and supplies into and out of the various theatres of war. The formal creation of the RNTS involved the establishment of a new title for the officers that operated the service – that of transport officer – with the following titles and equivalent Royal Navy ranks:

Table 2: Royal National Transport Service Ranks with Royal Navy Equivalents

RNTS officer rank	Equivalent Royal Navy rank
Principal Naval Transport Officer	If already a flag officer this rank retained, but otherwise equivalent to commodore (2nd class)
Divisional Naval Transport Officer	Captain
Transport Officer, 1st grade	Commander, unless already of higher rank in which case that rank retained
Transport Officer, 2nd grade	Lieutenant commander
Transport Officer, 3rd grade	Lieutenant
Transport Officer, 4th grade	Sub-lieutenant or warrant officer

The cuff stripes worn by these officers depended on where they originated, since they might come from the Royal Navy, the Royal Naval Reserve or Royal Naval Volunteer Reserve. Their stripes generally matched the service they came from (see Chapters 3 and 5). The RNTS also recruited men from the civil branch of the Royal Navy and reserves (e.g. paymasters) and these kept the cuff stripes appropriate to their origins as well. RNTS officers were distinguished by a cap badge that is usually only identifiable in photographs using a lens. It was adapted from the conventional Royal Navy officer's cap badge, but carried a wide blue circle around the naval anchor bearing the words 'RN Transport' in gold lettering.

Figure 87 provides two examples of RNTS officers from 1917, with both wearing the RNTS cap badge. A close-up of this badge is also shown in the inset. The two cuff stripes without a curl indicate that the officer on the left was from the civil branch of the Royal Navy, rather than the military side, and had the equivalent rank of lieutenant (e.g. Electrical Lieutenant) and so he became a transport officer 3rd grade in the RNTS. The officer on the right in Figure 87

shows an officer in the RNTS who came from the reservists. He is wearing the wiggling cuff stripe of the 'wavy navy', the Royal Naval Volunteer Reserve, and since he does not have an executive curl he is from the civil branch as well, in this case with the rank of sub-lieutenant. His RNTS rank would have been transport officer, 4th grade.

Example Records for RNTS Ancestors
To follow the careers of men in the RNTS, you will need to pursue records related to their career in the Royal Navy or reserves.

Royal Fleet Auxiliary
The Royal Fleet Auxiliary (RFA) has supplied the needs of Royal Navy ships at sea since 1905. It was a service that arose originally

87. Two civil branch officers in the RNTS during the First World War: from the Royal Navy (left) and the RNVR (right). The inset shows the RNTS cap badge.

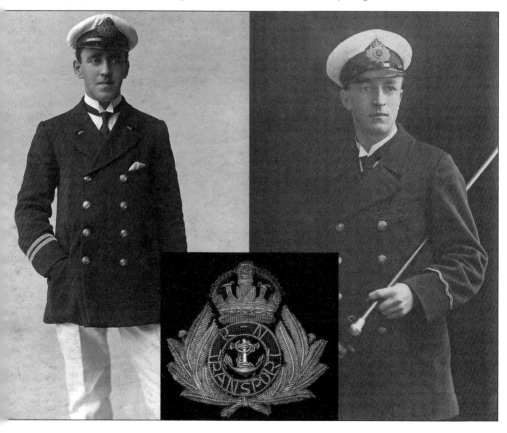

from the need to supply warships with coal when away from port, but subsequently this replenishment role expanded to include other forms of fuel, as well as supplies and ammunition.

Although the service is an essential support to the Royal Navy, the crews have been mainly civilian and sourced from the merchant navy. Occasionally, there are photos of seamen wearing Royal Navy style uniforms with 'Fleet Auxiliary' on their cap tallies and these were probably reservists.

There was an official cap badge available for RFA officers which was similar to the RNTS cap badge seen in Figure 87, except that the 'RN Transport' text within the circlet around the anchor was replaced with 'R – F – A'. Officers who wore this, continued to wear the cuff stripes of their original employer: usually that of the Royal Naval Reserve or merchant navy (see Chapters 5 and 2).

Example Records for Royal Fleet Auxiliary Ancestors
Records for most personnel can be found by researching the individual's merchant navy and/or Royal Naval Reserve career, but the Fleet Air Arm Museum archive holds selected RFA records, http://www.fleetairarm.com/naval-aviation-research.aspx. There is also a valuable website which includes career details for some personnel at www.historicalrfa.org.

Chapter 5

RESERVIST PERSONNEL OF THE ROYAL NAVY

Over the centuries, British politicians and monarchs have preferred not to maintain a large military force afloat in peacetime. It has proved costly to maintain and equip a sizeable fleet of Royal Navy ships, let alone pay the wages and upkeep of seagoing personnel. However, Britain relied upon her military superiority at sea repeatedly during the eighteenth century, and during the nineteenth century there was an expectation that it would be needed again even though the defeat of Napoleon heralded a considerable downsizing. Consequently, in Victorian times successive governments tried to do two things simultaneously: keep a peacetime navy within manageable 'affordable' proportions, while at the same time ensuring that it could be speedily brought up to full force if a conflict loomed.

Before the 1830s impressment helped meet the emergency need for crewmen that was created in wartime, but the brutal practice of the press gangs was deeply unpopular and became morally and legally indefensible so it had to be abandoned. Casting around for a different solution, the government hit on the idea of compulsory registration for merchant seamen in 1835. This would mean that suitably experienced mariners could be quickly identified for naval recruitment when necessary. However, the enormous task of registering every seaman proved too burdensome in administrative terms, and after various attempts at revision it ceased in 1857. Yet, the problem of quickly upsizing the navy in the event of war remained, and the idea of creating a formal reservist force was postulated.

Royal Naval Reserve

The registration of civilian seamen was almost immediately superseded by the new reservist initiative in 1859: the Royal Naval Reserve (RNR). This marked a significant departure from the earlier attempts to provide back-up to the navy. In particular, reservist seamen were legally enlisted as volunteers, they were offered appropriate training in advance of military service, and most importantly they were paid – although admittedly not very much.

The uniform of the RNR was closely modelled on that of the Royal Navy, as would be expected, but with key differences, discussed below. However, dress regulations were sometimes adhered to less strictly.

If you discover an ancestor wearing an RNR uniform it is worthwhile investigating if they also had a career in the merchant navy or as a fisherman, since these two occupations generated many of the recruits.

Men serving in the RNR were entitled to the campaign medals of the Royal Navy if they saw suitable service, but there was also a long-service good conduct medal specifically for the RNR denoting fifteen years' good service (with wartime years each counting as double service). RNR personnel could also bear war chevrons, wound stripes and appropriate branch badges like their Royal Navy counterparts (see Chapter 3).

Seamen and Petty Officers

When in service or training, seamen in the RNR generally wore uniforms that indicated their reservist status clearly, although the exact manner in which this was shown has changed over time. Figure 88 shows an early example from about 1873 where the letters 'RNR' are sewn into a rectangle in the chest area of the seaman's jersey; in this case the letters have been inked in by the photographer. These letters can otherwise be hard to see on black and white photographs. The cap tally is indistinct as it often was in early photographs. As noted in previous chapters, recruitment to a new role was a common time to visit a photographer so that a career milestone was immortalised for the sitter and his family, and this is

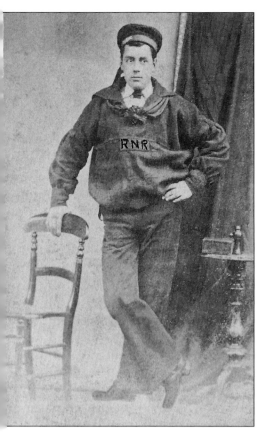

88. RNR seaman, c.1873.

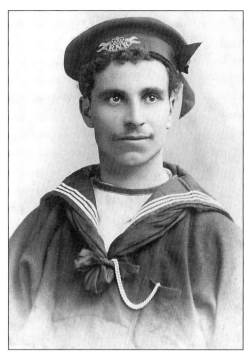

89. RNR seaman, c.1890.

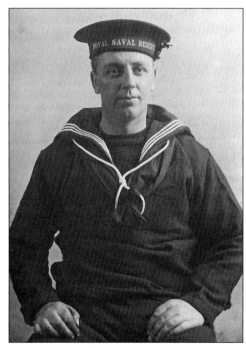

90. RNR seaman, c.1930.

possibly the case here. The seaman is wearing a collar and tie underneath his RNR frock, but before 1886 this was not unusual because not all seamen were provided with a full uniform by the navy; some decided to buy their own or bought only part of the uniform.

A later example of an RNR seaman from about 1890 is shown in Figure 89. Here the cap tally can be seen clearly and bears the letters 'RNR' below a Victorian crown. The more familiar portrayal of RNR seamen in the twentieth century is depicted in Figure 90, which dates from about 1930. Here the text 'Royal Naval Reserve' is sewn into the cap tally in full. In all other respects the uniforms of twentieth-century reservists were indistinguishable from their full-time Royal Navy colleagues.

Until 1905, seamen could not rise above the rank of able seaman in the RNR. However, in that year RNR men were permitted to become leading seamen and wear the fouled anchor on their left sleeve (see Figure 48). During the years that followed, up until the outbreak of the First World War, reservists were gradually enabled to take up many of the various specialist roles and more advanced ranks that were available to Royal Navy seamen. The reservist chief petty officers, engine room artificers and ratings not dressed as seamen in the RNR wore uniforms identical to their Royal Navy equivalents, but their cap badges incorporated the letters 'RNR' between the anchor and the crown until 1921.

Military Officers

It was soon realised that reservist seamen were not enough: the captains and mates of merchant ships offered an ideal pool for creating a reserve service of officers as well. These reservist officers initially consisted mainly of RNR lieutenants and sub-lieutenants who ranked below their equivalents in the Royal Navy. However, some men of ability were promoted to full-time ranks in the Royal Navy proper, and there were also 'honorary' RNR officers of higher rank but they had no command authority. The active rank of captain in the RNR was only introduced in the First World War.

RNR officers had to be trained to the Royal Navy's satisfaction.

In the 1860s, for example, lieutenants had to attend twenty-eight days of drill and gunnery instruction per year, and were paid 10 shillings per day for doing so. A number of well-known historical figures were to become RNR officers including the explorer Ernest Shackleton and Edward Smith, captain of the *Titanic*.

Officers took intertwining gold braid on their cuffs as a sign of rank, with the loop or curl that signified full-time commissioned officers in the Royal Navy replaced by a six-pointed star. The number of stripes denoted rank in the same way as they did for conventional commissioned officers – one for sub-lieutenant, two for lieutenant etc. (compare to Figure 55). The star was usually joined to the rest of the braid, but sometimes sat a short distance above it. In 1915 the raised cord-like braid used for cuff stripes was replaced by flat gold lace since it wore out less quickly; this is sometimes a helpful dating clue in photographs.

From 1872 onwards, RNR officers' cap badges incorporated the letters 'RNR' between the crown and the anchor, and in photographs this can often easily be picked out with a lens. Figure 91 shows a commander in the RNR from the First World War. He has three cuff

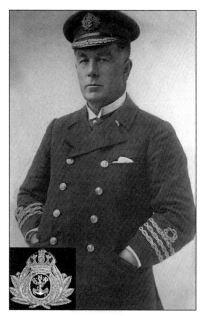

stripes like his Royal Navy counterpart and also the obligatory gold leaves on the peak of his cap – compare this to the Royal Navy commander shown on the front cover of this book which is from the same era. The inset of Figure 91 shows a close-up of the RNR cap badge.

A particularly common image to survive from the First World War is that of the RNR sub-lieutenant, who bore only a single cuff stripe. This is because many men appointed to this rank were ships' masters ('captains') from the merchant service who were awarded a temporary RNR commission. Their role was often to carry

91. RNR commander, First World War.

119

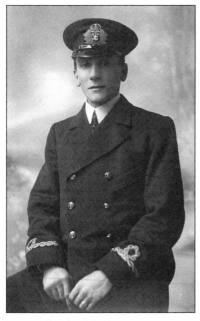

92. Sub-lieutenant in the RNR, First World War.

93. Early twentieth-century officer uniform buttons from left to right: RNR, RNVR and Royal Navy. These are just a few examples and there were many variations.

out official patrol duties as part of the defence of the British coast, or to command commercial ships in convoys. An example of an RNR sub-lieutenant can be seen in Figure 92. However, during wartime a ship's master with significant prior RNR or Royal Navy experience might be promoted straight to lieutenant RNR and given more substantial responsibility.

Officers employed in the merchant service were allowed to wear RNR buttons when not on reservist duty as part of their civilian uniform. Thus, occasionally a photograph of a merchant seamen may

reveal his links to military service if you can spot the letters 'RNR' on his buttons. There have been many variations on the basic Royal Navy button design, but all carry the fouled anchor surmounted by a crown. Figure 93 shows a typical example of an officer's RNR button, an RNVR button and a Royal Navy button from the early twentieth century. Buttons are sometimes a helpful clue to, or verification of, a seafarer's role, but unfortunately they often catch the flash from the camera or are otherwise indistinct so that even with a lens they cannot be seen clearly enough. RNR buttons usually carried a capital letter 'R' either side of the naval crown and fouled anchor with the middle letter 'N' of 'RNR' difficult to see because it sits on top of the anchor. Similarly, RNVR buttons displayed an 'R' and a 'V'. There were many variations on button design and these are just examples.

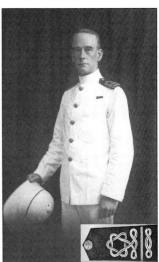

Figure 94 shows Lieutenant Commander Harold Watkins of the RNR who was based ashore when this photo was taken in Hong Kong in 1914. It illustrates that RNR officers carried their ranks on shoulder straps when wearing tropical uniforms in the same way that regular Royal Navy officers did. The stripes on the shoulder strap match those that would have been worn on the cuff. In this case, the officer is a lieutenant commander as indicated by a row of intertwined gold braid, then a narrow plain row and then the final row with its star-shaped curl. The inset shows the shoulder strap in better detail. This officer also has a ribbon stripe for the RNR Long Service Good Conduct Medal: the small rectangular stripe on the left side of his chest would have been dark green, and indicates fifteen reckonable years of RNR service.

94. Lieutenant Commander Harold Watkins, RNR wearing tropical shore uniform, 1914. The shoulder strap is shown in the close-up.

From 1921 onwards, RNR officers kept their distinctive cuff stripes but adopted the same cap badge and buttons as Royal Navy officers and so the letters 'RNR' were no longer incorporated into them. This can be a helpful tip

when trying to date a photograph. The distinctive cuff stripes of the RNR were abolished in 1951 and officers wore the same as their Royal Navy equivalents but with a capital letter 'R' within the executive curl.

Midshipmen and officer cadets in the RNR wore the same uniform as Royal Navy equivalents except that their collar twists and turnbacks were blue rather than white, so they show up less distinctly in black and white photographs.

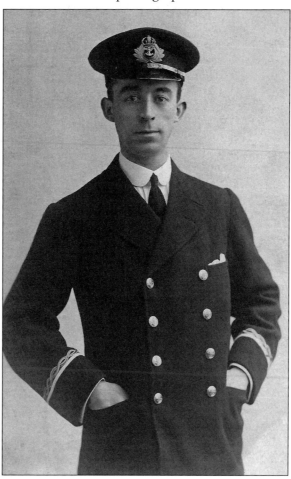

95. Paymaster sub-lieutenant, RNR, 1910s.

Civil Branch and Warrant Officers

These men wore the same dress as individuals with similar positions in the Royal Navy (see Chapter 3) and ranks were denoted with cuff stripes in the same manner, although each gold stripe was again replaced with an intertwined cord of undulating gold braid or ribbon as for RNR military officers. Figure 95, for example, shows an officer from the accountancy branch of the RNR from the First World War. He has one gold stripe consisting of intertwined gold braid, and a second plain white stripe showing his attachment to the accountancy section, thus his rank was paymaster sub-lieutenant. His cap badge again incorporates the letters 'RNR' between anchor and crown as it did for the military branch.

Example Records for RNR Ancestors

Some RNR personnel have part of their careers documented within Royal Navy records or merchant navy records. Most RNR-specific records are kept at TNA and there are research guides to this subject on its website at www.nationalarchives.gov.uk. RNR career documents available online include seamen's service records for 1908–55 as series BT 377/7, and officers' records from 1862 (for those who joined before 1920) in series ADM 240. Put an ancestor's name into the *advanced search* in TNA's Discovery facility at http://discovery.national archives.gov.uk/ and use the 'Search For Or Within References' feature to restrict your investigation to one of these series. The Fleet Air Arm Museum archives also hold some original RNR records, http://www. fleetairarm.com/naval-aviation-research.aspx.

For most records after 1920, next of kin must apply to the British government: type 'military service records' into the website http://www.gov.uk for more details.

Royal Naval Volunteer Reserve

The Royal Naval Volunteer Reserve (RNVR) was formed in 1903 in an attempt to further boost the reservists available to the Royal Navy. Unlike the RNR, men enlisting in the RNVR usually had limited prior seafaring experience. They were not recruited from among the

civilian seagoing professions and although many still went to sea, others were deployed to supporting roles in naval bases, as administrators, at training or research establishments and so forth. For example, the author Ian Fleming became an RNVR officer in the Second World War, but was based in Naval Intelligence at the Admiralty in London and was never sent to sea. There were some formal divisions of the RNVR with specific duties such as mine clearance, anti-aircraft activities or wireless training.

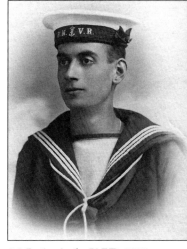

96. Rating in the RNVR, 1915.

The distinctive wiggling appearance of the RNVR's officer cuff stripes led to the service becoming known affectionately as the 'wavy navy'. These characteristic stripes were abandoned in 1951 and RNVR officers wore the same as their Royal Navy equivalents but with a capital letter 'R' within the executive curl. In 1958, the RNVR merged with the RNR.

RNVR recruits were entitled to earn a long-service good conduct medal which had the same dark-green ribbon as the RNR version until 1941.

Seamen and Petty Officers

Seamen in the RNVR were distinguished simply by the letters 'RNVR' on their cap tallies. Figure 96 shows an example from 1915. In peacetime, seamen in some divisions of the RNVR wore tallies that identified the geographical location of their training headquarters, for example, 'RNVR London'. Other such locations on tallies include Humber, Tyneside, Bristol, Mersey, Sussex, Wales and Clyde.

Chief petty officers, specialist ratings that did not dress as seamen, and engine-room artificers followed the same uniform patterns as their Royal Navy equivalents, except for the letters 'RNV' inserted in between the crown and anchor in the cap badge for the

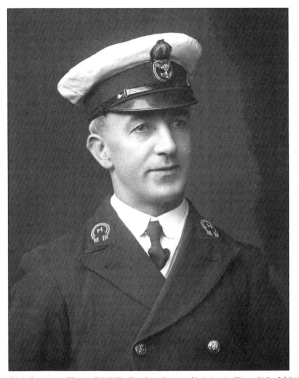

97. Chief petty officer, RNVR (hydrophone division), First World War.

period 1914–21. After this time the distinction was removed. Although the lettering 'RNV' was the form officially sanctioned, it is quite common to see the letters 'RNVR' on cap badges instead. Figure 97 shows a chief petty officer in the RNVR. He displays a very rare branch badge – that of the hydrophone division which was involved in listening for submarines, hence the headphones surrounding a letter 'H' on each lapel. His cap badge bears the lettering 'RNVR'.

Military Branch Officers
The cuff stripes for commissioned officers in the RNVR had a characteristic wiggle, as noted above. Otherwise the numbers of stripes indicating rank followed the same pattern as in the Royal

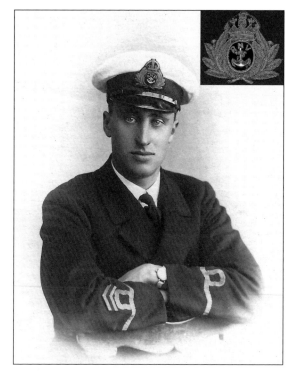

98. Sub-lieutenant, RNVR, 1916.

Navy, except that the curl was replaced by a square-ish loop (compare with Figure 55). Figure 98, for example, shows a RNVR sub-lieutenant in the First World War as indicated by his single cuff stripe with loop. In his particular case there are two war chevrons on his right sleeve as well, indicating two years of action in a war zone. These chevrons were initiated in 1916, but discontinued in 1922. His cap carries the 'RNV' lettering between crown and anchor, and is shown enlarged in the inset.

From 1921, the use of the letters 'RNV' or 'RNVR' on cap badges was officially abandoned, with all Royal Navy, RNR and RNVR personnel thereafter wearing the same cap badge. Reservists also adopted Royal Navy buttons. Hence the RNVR lieutenant commander seen in Figure 99 from 1942 has RNVR cuff stripes, but his cap badge in this black and white photo is indistinguishable from that of an Royal Navy commissioned officer.

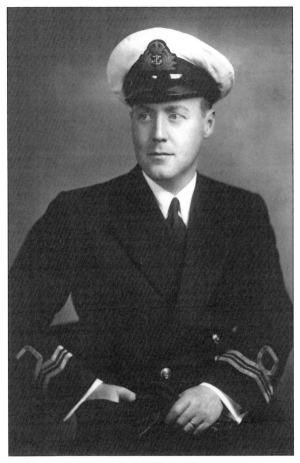

99. Lieutenant commander, RNVR, 1942.

Midshipmen and officer cadets in the RNVR wore the same uniform as their Royal Navy compatriots but their collar twists and turnbacks were maroon.

Civil Branch and Warrant Officers
Apart from distinctive RNVR sleeve stripes and a cap badge bearing 'RNV' until 1921, these officers were dressed in the same fashion as their Royal Navy equivalents. An example, who was actually

employed by the RNTS, can be seen in the right-hand image of Figure 87.

Example Records for RNVR Ancestors

Early RNVR career records are kept at TNA and there are research guides to this subject on its website at www.nationalarchives.gov.uk. For example, series ADM 337 has records related to both ratings (1903–19) and officers (1903–22) and these can be viewed online. Put an ancestor's name into the *advanced search* in TNA's Discovery facility at http://discovery.nationalarchives.gov.uk/ and use the 'Search For Or Within References' feature to restrict your investigation to ADM 337.

For most records after 1920, next of kin must apply to the British government: type 'military service records' into the website http://www.gov.uk for more details.

Other Reservists

There have been a number of other naval reservist organisations in existence at various points in time and although it is not possible to list them all here, you may be able to identify some of them from photographs. For example, in the nineteenth century you might discern the letters 'RNAV' on officers' cap badges or on buttons. This indicates membership of the Royal Naval Artillery Volunteers (RNAV), which sprang up in 1873 as a means to train civilians in the skills of naval gunnery but it was disbanded in 1891. RNAV officers wore the interwoven twisting gold braid with six-point star loops that were worn by RNR officers.

Another reservist force was the Royal Naval Motor Boat Reserve (RNMBR) which existed solely for the duration of the First World War to patrol the British coastline checking for enemy activity. Its officers wore RNVR uniforms. Figure 100 shows a chief motor mechanic in the RNMBR – his cap badge displays the letters RNMBR between the crown and anchor, but it cannot be clearly seen in this photo. However, 'MBR' also appears with a four-bladed propeller on his collars. This is quite commonly seen, but it was not in fact a standard badge and naval regulations in 1916 stipulated the letters

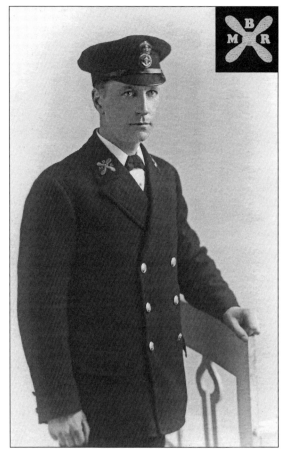

100. Chief petty officer (mechanic), RNMBR, First World War.

CMM be used (chief motor mechanic) or MM (motor mechanic).

The Royal Fleet Reserve (RFR) was an organisation for Royal Navy personnel who had completed at least five years' service but instead of leaving completely they agreed to be available for future deployment should an emergency arise. The RFR consisted mainly of seamen and stokers and had its own Long Service Good Conduct Medal. These men might wear 'Fleet Reserve' on their cap tallies when training, but when mobilised they wore conventional Royal Navy uniforms: Figure 3 shows a fleet reservist on mobilisation in

the Second World War and his cap tally displays HMS *Vernon*.

Skippers of fishing trawlers and their crews were also enlisted to form their own unit in 1910 – the RNR Trawler section (RNRT), which often operated minesweepers. Reservist seamen in this unit could sport the letters 'RNR T' on the upper arms of their jerseys – either beneath an existing branch badge or in isolation. But otherwise uniforms were similar to other RNR employees. Officers in the RNRT took the intertwining braid of the RNR, but there were some changes in title: a sub-lieutenant was known as a 'chief skipper', for example. The RNRT merged with the RNR in 1921.

The Royal Naval Auxiliary Sick Berth Reserve (RNASBR) was created in 1903, with members being recruited from the St John Ambulance Brigade to tend to injured servicemen. It was disbanded in 1949. Figure 101 shows a man with the equivalent rank of 'Seaman' in the RNASBR sporting the distinctive medical cross as a branch badge on his right arm, beneath which are the letters 'SBR'. This picture was taken in about 1910.

Royal Naval Division

At the beginning of the First World War the Royal Navy fleet was soon fully manned, and the service realised it had an excess of reservists. The Admiralty organised these surplus men from the RNR, RNVR and RFR, together with marines, to form a division of infantry that was known as the Royal Naval Division (RND). They were trained and fought as soldiers, and did not operate on warships. Helpfully, many of them already had experience of modern weaponry since reservists were mandated to undertake armaments training.

Seamen in the RND were originally marked out by the words 'Royal Naval Division' on their cap tallies, instead of the name of a ship and Figure 102 shows an example of this from 1914. Later in the war, a metal cap badge bearing the letters 'RND' was also used. These designations tended to be worn before allocation to a specific battalion. Figure 102 is a studio portrait, but demonstrates the use by the photographer of a military backdrop to give the impression that the seaman is standing on the deck of a battleship. This is

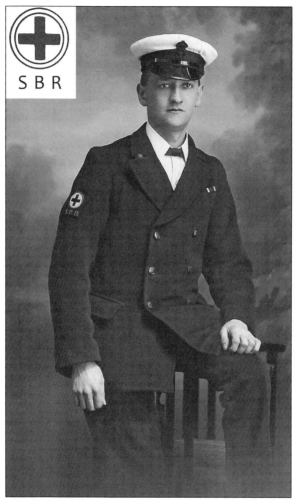

101. Man with rank of 'Seaman', RNASBR, 1910.

somewhat ironic in view of the fact that this young man was effectively being sent to combat on land as a soldier not to fight at sea. Backdrops of this nature were usually painted onto large screens set up behind the subject and were intended to emphasise their military resolve in a dramatic manner.

There were originally eight RND battalions of 'seamen' formed

into two brigades, plus a third brigade of Royal Marines. The seamen battalions were named after famous British admirals:

1st Brigade: Benbow, Drake, Collingwood, Hawke
2nd Brigade: Anson, Hood, Howe, Nelson

The Collingwood and Benbow battalions were disbanded after the Gallipoli campaign as a result of heavy losses. Early in the war, RND seamen were deployed wearing traditional Royal Navy attire even after allocation to a battalion and an example is shown in Figure 103, where a seaman wears a Hawke battalion cap tally but is otherwise attired as per a regular Royal Navy rating.

By 1916, the RND had adopted khaki uniforms similar to the army, but they had continued to maintain elements of their naval uniform. Figure 104 shows an example of this. The seaman sitting in front is a regular Royal Navy rating in conventional uniform, but the two seamen standing behind are dressed in army style uniforms, complete with swagger sticks, and wear Royal Navy style caps in khaki bearing the name 'Royal Naval Division' on the tally. The white lanyard around the neck of the seaman sat down is replaced by a lanyard looped over the shoulder in the two men standing.

From May 1916 onwards, the RND were sent to the Western Front and were renamed as the 63rd (RN) Division, but were supplemented with some army battalions. Its men had been formally awarded metal cap badges denoting each of their battalions which were soon adopted. In photographs, these cap badges are often the only means by

102. Newly enlisted RND seaman, 1914.

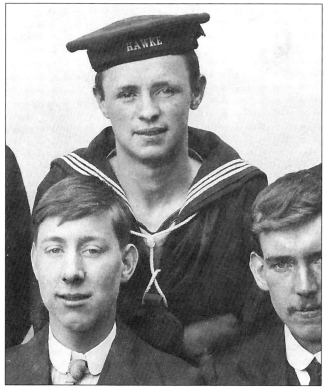

103. A rating in the Hawke battalion of the RND, 1916.

which it can be easily determined that an individual served with the RND, as in all other respects they can be difficult to differentiate from soldiers of the regular army. The full range of official cap badges used by the RND battalions when in 'army style' uniform after 1915 are shown in Figure 105.

Although dressed as soldiers, RND men often kept their branch badges and rank insignia in the navy fashion, and this can provide an additional clue to RND status. Sometimes a metal badge carrying the letters 'RND' can be seen on the shoulders. Figure 106 shows a leading seaman as demonstrated by the fouled anchor embroidered in khaki on his left arm. However, he is wearing an army style khaki uniform with a peaked cap (which was issued when the RND went

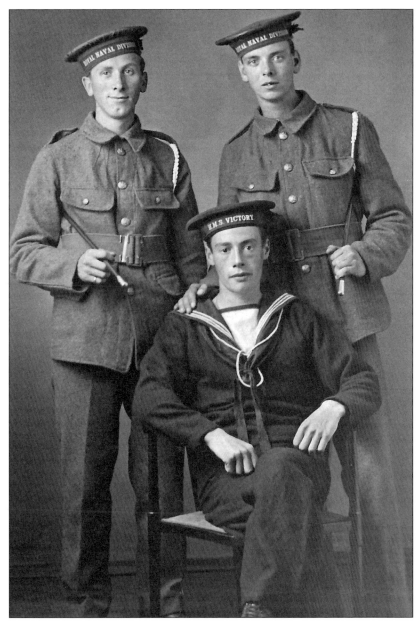

104. RND seamen (standing) with a conventional Royal Navy rating (seated), 1916.

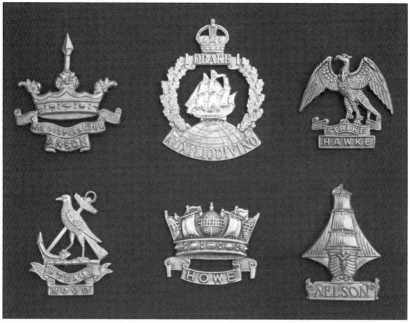

105. Cap badges for RND battalions in the First World War. Top row, left to right: Anson, Drake and Hawke. Bottom row: Hood, Howe and Nelson.

to the Western Front), and his metal cap badge depicts the Anson battalion. Interestingly, on his right arm you can just see the two stripes of his equivalent army rank of corporal. The three horizontal bars on his left forearm are wound stripes, each one being awarded for separate serious injury in combat. They were introduced in 1916, but not worn after 1922.

Some RND personnel were allocated to the machine-gun corps, which already had its own army cap badge consisting of two crossed guns. Men in the RND who joined the corps can be identified by the letters 'RND' attached beneath this badge. An example is shown in a family photograph of 1917 in Figure 107, together with an inset featuring the badge itself.

Finally, Royal Navy officers employed ashore outside Britain in the First World War also wore the khaki service dress of the army. An officer's naval cuff stripes could be replaced by stripes in khaki to

106. Leading seaman in Anson battalion of the RND, c.1916. (Courtesy of Geoff Caulton, www.photodetective .co.uk)

the same naval design, or officers might wear their equivalent army rank on shoulder straps in the army style. The officer's embroidered Royal Navy cap badge with its laurel leaf surround could be exchanged for a bronze version by men in the front line. Figure 107 shows a naval officer in khaki, standing to the right of the others in the photograph. He has his naval officer's cap badge, and three 'pips' on his shoulder strap: this is the army rank of captain, equivalent to a lieutenant in the Royal Navy.

Example Records for RND Ancestors
RND personnel records are kept at TNA and there are research guides to this subject on its website at www.nationalarchives.gov.uk. For example, series ADM 339 has service records for RND officers

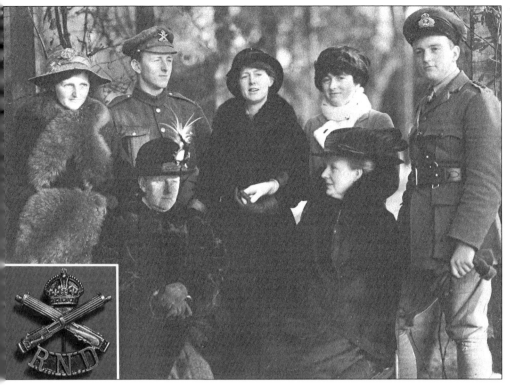

107. A RND seaman in the machine-gun corps (back row, left) and a naval lieutenant in the army style service uniform of a captain, c.1916.

and ratings. Put an ancestor's name into the *advanced search* in TNA's Discovery facility at http://discovery.nationalarchives.gov.uk/ and use the 'Search For Or Within References' feature to restrict your investigation to ADM 339. The subscription website www.ancestry. co.uk also features this series, as well as RND casualty records which contain career details. You may need to search Royal Navy, RNR, RNVR or Royal Marine sources separately as well, depending upon your ancestor's route into RND and their subsequent career.

Chapter 6

OTHER SEAFARERS

Lifeboatmen
The National Institution for the Preservation of Life from Shipwreck was founded in 1824 by William Hilary and sought to appoint lifeboats at strategic points all around the coast of Britain. In 1854, when Queen Victoria bestowed her patronage on the organisation, it changed its name to the Royal National Lifeboat Institution (RNLI) which is the designation that has survived to the present day. Lifeboatmen were appointed as volunteers and there was no complete uniform as such, but photographs of crewmen often reveal their lifeboat service connections.

Lifeboatmen were photographed quite frequently because communities were proud of their crews, and in the twentieth century the RNLI often sold photographs and postcards as part of its fund-raising operations.

108. Great Yarmouth lifeboat crew, c.1900.

A traditional pose for lifeboatmen in old photographs is the crew assembled either in front of their lifeboat or inside it. Figure 108 shows an example of this: the crew of the Great Yarmouth lifeboat, *John Burch*, taken in about 1900 with the lifeboat behind them.

In these types of 'publicity' shots, the coxswain is usually in the centre of the front row, as here. When lifeboatmen are pictured standing or seated inside their vessel in the pre-engine era, then typically the coxswain is placed nearest the stern and often holding the tiller. The bowman, as his name suggests, is usually at the bows. The coxswain sat rearmost since in a boat propelled by oars he could face forwards and see what was going on and thus give directions and steer the

109. RNLI coxswain's badge, 1920s.

boat. The bowman's role was to have a grapnel ready to hook on to a vessel in distress and to look out for wreckage or survivors in the water immediately ahead. Group photos will often yield clues about the location where the photo was taken because of buildings in the background, and of course the lifeboat's name (if visible) is extremely helpful in identifying a specific crew and era.

Many lifeboatmen were fishermen, but others were pilots, ferrymen, or served on yacht crews, and the clothes they wear in group lifeboat photographs may provide hints to these roles.

In Figure 108, the coxswain seated with his dog is wearing an RNLI coxswain's cap badge, which consisted of a crown above a fouled anchor and it is in some ways similar to the Royal Navy cap badge. However, it bears the initial letters of the lifeboat institution above the anchor. Between about 1900 and the early 1930s the letters R-N-L-B-I were used because the word 'life-boat' was then usually hyphenated. After this time the more familiar RNLI was adopted. The circle of gold braid surrounding the anchor is particularly thick and tends to stand out in photographs. A close-up of the cap badge is depicted in Figure 109. Note that some coxswains elected not to wear the badge and preferred to be dressed in the same way as the rest of the crew.

A second common pose for lifeboatmen was a studio-style portrait wearing a life jacket, and an example can be seen in Figure 110 which dates from about 1890. The cork life jacket worn by this lifeboatman was of a very characteristic design. It was invented for the RNLI by Captain John Ward in 1854, and it is common in photos of lifeboatmen throughout the Victorian era. It consists of blocks of cork stitched onto a canvas vest. The cork blocks were distributed around the waist and across the chest and back, and were designed to keep the head above the water if a lifeboatmen was washed overboard. The design allowed freedom of arm movements so that the wearer could still row the lifeboat or swim. The lifeboatman in Figure 110 also wears an oilskin hat and coat. The coat in this example is quite long so that it protected the lifeboatman's knees from soaking while he was rowing the boat, but shorter varieties stopping just below the waist were worn too. Crews might also wear waterproof boots or leggings. This man carries a scroll in his hand which might perhaps be a testimonial for bravery from the RNLI or other organisation.

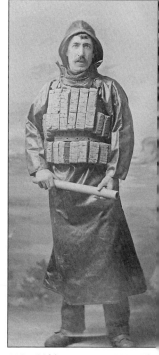

110. Lifeboatman, 1890. The rolled sheet he is holding might be a bravery testimonial.

The cork life jackets favoured by the RNLI began to be phased out at the beginning of the twentieth century. In 1904 a new type of jacket was created, filled with the fluffy, buoyant and water-resistant plant material known as kapok, and this was quickly adopted. Figure 111 features Thomas Rimmer, coxswain of the Lytham St Anne's lifeboat, Lancashire, photographed in about 1910, wearing a kapok life jacket on top of a standard issue RNLI oilskin jacket.

Other features that may be detected in photos of lifeboatmen are the letters RNLBI or RNLI woven into the chest of jerseys. A lens may be needed to see them because the lettering was small, and sometimes in red which does not show up well in black and white

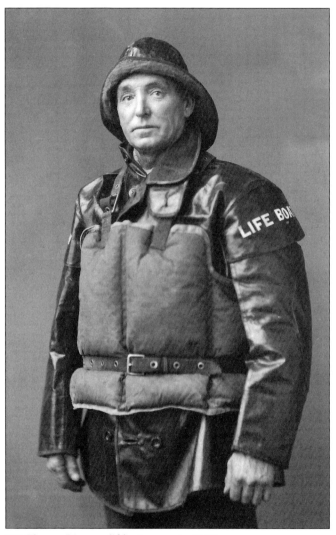

111.Thomas Rimmer, lifeboat coxswain, 1910.

photographs. Once kapok life jackets were introduced then some crews painted their ranks onto them such as: 1st cox, 2nd cox, 1st mech ('mechanic'), 2nd mech, bowman. The mechanic was effectively the engineer for motorised lifeboats. Some time in about the 1930s the

RNLI introduced a specific badge for its mechanics. This was similar to the coxswain's badge except that the anchor was replaced by a three-bladed propeller.

Example Records for Lifeboatmen Ancestors

The RNLI website at http://rnli.org identifies lifeboat stations and includes brief historical details, although some stations have a more detailed local website too. The RNLI's publication *The Lifeboat Journal* (from 1852) often recorded lifeboat actions, awards and coxswains and this is available digitally; a memorial near the RNLI headquarters in Poole lists all men who have died in pursuit of their duty since 1824. Look in the 'About Us' section of the RNLI website for details of both of these, together with information about the RNLI's own archive service. If an ancestor received the Institution's medal then there is a published index: *Lifeboat Gallantry – The Complete Record of RNLI Gallantry Medals and How They Were Won 1824–1996* (Barry Cox, 1998). Local newspapers are generally a very good source for lifeboatmen.

Yacht Crews

Yachts were employed as private pleasure craft by wealthy families who might take an extended holiday to, say, the Mediterranean on their own vessel for the summer, but they were also used for racing. These vessels could be quite big and were usually crewed by professional seamen.

Since the owners of larger yachts and racing yachts were usually persons of status, they sought to bestow a certain feeling of pride and identity on the men who worked their vessel. Consequently, starting in about the 1870s, many wealthy yacht owners began to commission jerseys embroidered with the name of their vessel for the crew to wear. Typically, the yacht's name appears on the chest of the jersey inside an embroidered box of various shapes, and these names are usually clear and readable even in very old photographs.

Figure 112 shows a crewmember of a yacht from the 1880s. The name of the yacht on his jersey is the *Garland*, embroidered in a curved box across his chest and on his cap tally. His jersey also

112. Crewman of the yacht Garland, *c.1880.*

records the name of the yacht club at which the vessel was based: the letters 'RSYC' stand for the Royal Southampton Yacht Club.

There are a very large number of British yacht clubs and some examples are listed below, together with the years in which they were founded. People who were wealthy enough to afford to provide uniforms for their yacht crews almost invariably joined the most prestigious yacht clubs, hence the focus in this list is on clubs with a 'Royal' appellation. Note that some clubs have historically used the same or similar initials, and many have changed their name at least

once. The address of the photographer on an image may help you identify a likely yacht club abbreviation; alternatively, the vessel's entry in *Lloyd's Register of Yachts* or the *Mercantile Naval List* should specify its home port. The photographer's address in Southampton is stamped on the back of Figure 112, for example, and the owner is listed as Mrs Annie Yorke of Southampton in the *Mercantile Naval List*.

Table 3: British Yacht Clubs

Abbreviation	Yacht club and base	Year name adopted
RCYC	Royal Clyde Yacht Club, Hunters Quay	1856
RCYC	Royal Corinthian Yacht Club (Kent originally, but then Essex from 1931, and Cowes as well from 1948)	1872
RFYC	Royal Forth Yacht Club, Edinburgh	1883
RHYC	Royal Harwich Yacht Club, Harwich	1845
RHYC	Royal Highland Yacht Club, Oban	1881
RNYC	Royal Northern Yacht Club, Rothesay (until 1937 then Rhu)	1830
RNYC	Royal Northumberland Yacht Club, Blyth nr Newcastle	1890
RSYC	Royal Southampton Yacht Club, Southampton	1870
RTYC	Royal Tay Yacht Club, Dundee	1891
RTYC	Royal Thames Yacht Club, London	1830
RWYC	Royal Western Yacht Club, Plymouth	1833
RYS	Royal Yacht Squadron, Cowes	1833

Sometimes enthusiastic owners or yacht club officials can be seen wearing caps that carry their yacht club emblem. Figure 113, for example, shows the Prince of Wales (later Edward VII) in about 1882 when he was appointed commodore of the Royal Yacht Squadron at

Cowes. His cap displays the RYS emblem (shown enlarged in the inset).

Care should be taken when reading yacht names from crewmen's jerseys as some bear the prefix 'SY' in front of the vessel's name for 'sailing yacht'; this should not be confused with other similar prefixes such as 'SV' (sailing vessels such as barques) or 'SS' (steam ships).

Figure 114 shows the full crew of the yacht *Oimara* in about 1900. Once again, the seamen on the crew have jerseys bearing the yacht's name in a box, and cap tallies with the same information. Their jerseys identify the yacht club as 'RNYC', but *Lloyd's Register of Yachts* identifies more than one yacht with this name. However, the captain has his hand on the ship's speed

113. Prince of Wales wearing a Royal Yacht Squadron cap, c.1882.

telegraph so the vessel in the photograph must have an engine. The only yacht with an engine called *Oimara* in *Lloyd's Register* was

114. Crew of the yacht Oimara, *c.1900.*

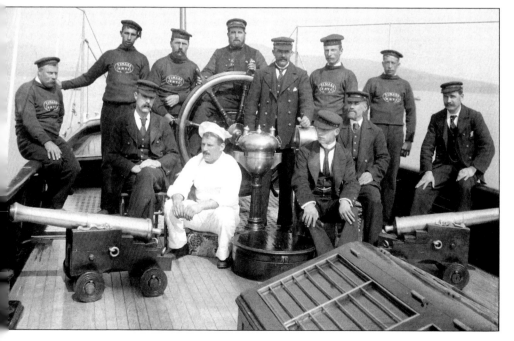

owned by Robert Ingham Clark and based at Glasgow. So 'RNYC' is most likely the Royal Northern Yacht Club.

In Figure 114, note that unlike the seamen on board, the vessel's officers do not have named jerseys or cap tallies and this was usual practice. Officers could include the captain (or master), an engineer if it had an engine (as here) and at least one mate. In this photo the wealth of the *Oimara*'s owner is revealed since the yacht had its own chef.

Example Records for Yacht Crew Ancestors
Yacht crews can usually be found by following the search tips provided for the merchant navy. In addition, the activities of racing yachts were frequently reported in contemporary newspapers, and an index of vessels and their owners was published regularly: *Lloyd's Register of Yachts* dates from 1878. The TNA online research guide to Crew Lists at http://nationalarchives.gov.uk may help you find crewmen on a named yacht.

Fishermen
The range of clothing worn by fishermen is varied, and in old photographs their apparel may be impossible to differentiate from certain other maritime professions, particularly the crews of coastal merchant ships as these men often did not wear a uniform. However, fishermen tend to be associated with three particular clothing items: the hand-knitted jersey (or Guernsey) and oilskin hats and coats.

Yet there may be important clues in the background to assist you. A photograph on the front cover of this book, for example, features a fisherman in the 1880s. He is shown with small boats for inshore fishing behind him and he is handling a net – fairly obvious indications of his profession.

Figures 115 and 116 shows two groups of fishermen from Sheringham in Norfolk. The first of these was taken in the 1880s and the lobster pot in the foreground is clear evidence of their occupation. These pots vary in style depending upon the location. The men are dressed in hand-knitted jerseys, rough baggy working

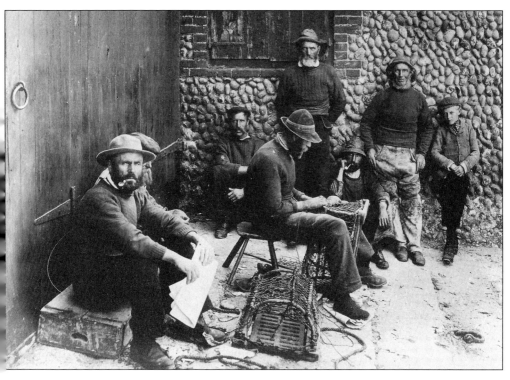

115. Fishermen from Sheringham, Norfolk, c.1880s.

116. Fishermen from Sheringham, Norfolk, c.1910.

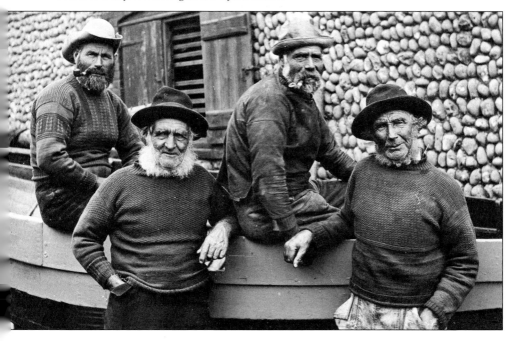

trousers and a range of headwear. Three of the men against the back wall are wearing a sou'wester, a hat that was made of oilskin. Standing with the men at the back is a young boy; he was probably the son of one of the fishermen and in the process of learning the ropes for a future fishing career. Boys often started going to sea at around 10 years of age.

Figure 116 is a later image dating to about 1910, and further illustrates the range of headgear that fishermen wore. It also shows how the wives and female members of a fisherman's family were creative in knitting jerseys for them – a range of designs is on display here. Indeed, some families had favourite patterns which were adopted from one generation to the next.

It is interesting to compare Figure 116 with the bottom image in Figure 37, which dates from the same era but depicts the crew of a coastal merchant navy vessel. Note that although there are similarities, such as the wearing of knitted jerseys by some crewmen, there are differences in the headwear worn. The coastal cruiser crew have adopted flat caps and felt hats which were often not favoured by professional fishermen when at sea because they were not waterproof. Inshore fishermen also tended to prefer hats with a fairly wide front brim or a peaked cap because they set out early in the morning when the sun was low in the sky and needed to keep it out of their eyes. Warmth in the winter was a third factor that helped determine the style of hat and clothing worn.

One particularly popular piece of fishermen's headwear was the sou'wester, renowned for keeping the head dry when conditions were wet, but often worn at other times when working, as seen in Figure 115. The sou'wester is illustrated in more detail in Figure 117. Note the brim which could be turned up or down – when turned down it helped to keep rain and spray out of the eyes – and the extended rear of the sou'wester prevented water running down the back of the neck. This fisherman is also wearing a waterproof oilskin coat that could be buttoned high up the neck to keep the water out, and which traditionally accompanied the sou'wester in rainy weather. A full-length version of the oilskin can be seen in the illustration of the lifeboatman in Figure 110.

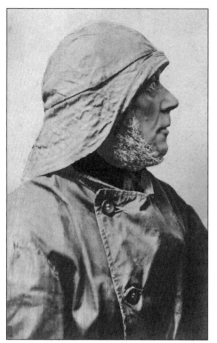

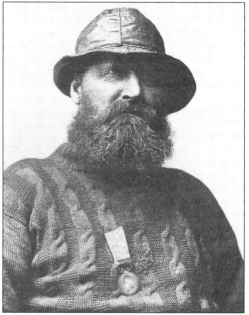

118. Henry Freeman from Whitby, 1890s. He was a famous lifeboatman, but earned his living as a fisherman.

117. Fisherman wearing a sou'wester, c.1900.

A good view of a different kind of oilskin hat is shown in Figure 118. The wearer here is Henry Freeman from Whitby in Yorkshire in the 1890s, and the hat has a wide brim all the way around. His jersey demonstrates a very different pattern to those from Sheringham. Henry was also a lifeboatman, and the medal he wears is the RNLI silver medal awarded him in 1861.

Figure 119 is from further north again, from Scotland in the 1890s. This charming photograph demonstrates yet more variation in the way that a fisherman might dress. Here the man in question wears a knitted woollen hat for warmth, and a thick overcoat and scarf. He is also smoking a clay pipe: a very widespread practice among all seafarers. It was considered a sociable thing to do and was cheap. There are fishermen smoking in Figures 115 and 116 as well.

When working, fishermen often wore sea boots that came to

above the knee, and these can sometimes be seen in old photographs (e.g. look at the left-hand-most man in Figure 108). In the Victorian era the boots were made of close-fitting untanned leather which was unfortunate because they were very difficult to kick off quickly if a man fell overboard, and hence they contributed to some drownings (although many seafarers could not swim anyway).

Fishermen's wives or fishwives were married to fishermen and were often responsible for selling the fish that their husbands caught. They could also perform a variety of other roles including gutting and preparing fish for sale, smoking fish, gathering bait and repairing nets and clothing. The fishwife was an iconic image of Victorian Scotland and was frequently photographed in places such as Edinburgh, Arbroath and Nairn carrying the large basket or creel used for transporting fish for sale around the streets. In Edinburgh they often wore distinctive striped dresses and this is illustrated in Figure 120.

Fishwives were also important in other large fishing communities elsewhere in Britain, such as Cornwall and Tyneside. Figure 121 shows four 'fish lasses' from Cullercoats in Northumberland. These were described as follows:

> The fisherman's help-mate generally, is his wife, who is often scarcely inferior in muscular strength to himself . . . The fish-woman acts as the sale-woman of the fish caught by her father, husband or brother as the case may be. Each morning these women may be seen making their way across the 'Long Sands' with their fish-creels strapped upon their broad shoulders and soon in the streets of Tynemouth and Newcastle is heard the cry of 'fresh herrings, caller herrings!' and other similarly tempting announcements delivered with the strong intonation of their northern dialect. When the women are not employed in this way, you may see them sitting at their doors mending the crab-nets, cleaning and preparing the fish, or patching the great worn sail of a fishing smack. (*Chatterbox* magazine, 1868)

119. A Scottish fisherman, c.1900.

120. An Edinburgh fishwife, c.1870.

In former times Scotland was famed for its 'fisher girls'. These itinerant ladies would journey to the eastern ports of Scotland and England from Lerwick to Lowestoft to process the large catches of herrings that used to be caught there. Starting in the northern ports in spring they migrated down the coast to reach East Anglia by the autumn, their busiest time, where they would stay for around two months. Even in the 1930s there were as many as 4,000 fisher girls in East Anglia every October. They would gut vast quantities of herrings with incredible speed and dexterity, the resulting produce

121. 'Fish lasses' from Cullercoats, Northumberland, c.1900.

122. Scottish fisher girls at work, 1890s.

being packed into large brine-filled barrels. Figure 122 shows a group of Scottish fisher girls in their short-sleeves and head scarves, which were always noted for being brightly coloured. Although not very clear in this photograph, they wore an oilskin pinafore or apron. Despite being called 'girls', they did vary considerably in their ages, as the photo illustrates.

Example Records for Fishermen Ancestors

Local record offices are usually the best place to start finding fishermen in their vicinity. However, there are national registers of skippers and mates of fishing vessels (BT 129 and BT 130) at TNA, and these are indexed by BT 138 (1880–1917) and BT 352 (1917–69). You must visit TNA to see these, as well as the ship registration documents dating from 1786 in BT 107, BT 108 and BT 110 that include many fishing vessels. TNA's website also has a research guide to ships' crew lists which often identify fishermen, www.nationalarchives.gov.uk (look under 'C' in the A to Z list). After 1855, the annually published *Mercantile Navy List* identifies every British ship over ¼ ton together with its owner.

Pilots

The pilot's job was to act as a navigator for ships coming into port or journeying through particular stretches of water. He developed a detailed knowledge of the potential dangers so that he could safely guide ships on their way. Pilots traditionally shared a single pilot station, set up at a prominent coastal location, and ships requiring assistance would fly a special flag to request a pilot to come on board. Until the late nineteenth century, most pilots traditionally operated from small wooden sailing vessels called cutters, and had to display their warrant ('licence') number prominently on the sail.

Pilots were paid per ship navigated, and there were agreed rates according to the size of the ship and the distance it was taken under command of a pilot. When a pilot came on board he might take the helm personally, or stand next to the helmsman and give him instructions.

After 1853, Trinity House in London regulated British coastal

pilots except for those operating from Liverpool, Bristol, Hull, Newcastle and Scotland, which had their own local regulatory authorities. Trinity House did not employ them directly – they were effectively self-employed – but it did license them, and without a proper warrant it became illegal to practise as a pilot.

123. Trinity House pilot cap badge.

In the twentieth century, some Trinity House pilots adopted a cap badge depicting a lion above a fouled anchor to identify themselves and this is shown in Figure 123.

Ports that had their own resident regulator, such as Liverpool with its Mersey Docks and Harbour Board, could adopt local means of identifying their pilots. This often included a distinctive cap badge that was unique to that port. Figure 124 shows pilots and the ship's crew on board Liverpool's first steam pilot vessel, the *Francis Henderson*, in about 1900.

Example Records for Pilot Ancestors

Records for Trinity House in London cover a high proportion of pilots in England and are not confined to the capital; they are kept at the London Metropolitan Archive and include national lists of pilots recognised by Trinity House and the national pilotage committee minutes which frequently mentions individuals (from 1808). Records for pilots not accountable to Trinity House in London are kept by local record offices. For example, Liverpool (Merseyside Maritime Archives & Library), Hull (Hull History Centre), the Newcastle area (Trinity House Newcastle), Bristol (Bristol Record Office) and Scotland (Trinity House Leith records at the National Archives of Scotland).

Coastguards

Photographs of coastguards in the Victorian era and in the early twentieth century show them in Royal Navy uniforms. Non-officers

124. Crew of the pilot vessel Francis Henderson, *c.1900.*

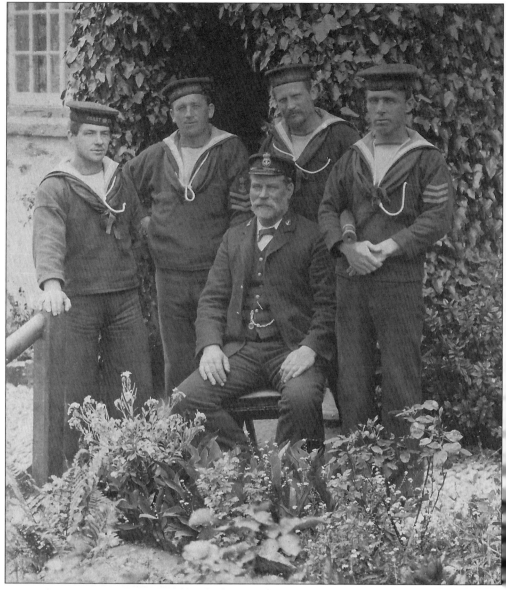

125. London coastguards, 1900. At this time the service was part of the Royal Navy.

were dressed as Royal Navy ratings but carried the text 'Coast Guard' on their cap tallies instead of the name of a ship. Usually, this is displayed in the form of the words 'Coast' and 'Guard' with a crown separating the two words. The equivalent of petty officers and commissioned officers also wore Royal Navy uniforms.

An example is shown in Figure 125 dating from about 1900. The picture was taken in London and shows four coastguards or 'boatmen' in their Royal Navy rating uniforms – note that they were entitled to wear selected naval insignia and two of the men wear good conduct chevrons on their left arms. The man sitting down is a chief petty officer as demonstrated by the two anchors on his collar. The anchors were used to denote a man who had risen to the rank of chief petty officer as a seaman but without a gunnery qualification. During the era of Admiralty control many men transferred to the coastguard from the Royal Navy bringing their earlier career experience with them.

However, in 1923 the control of the coastguard service was moved from the Admiralty to the Board of Trade and this resulted in a change of uniform. At this time a new 'CG' logo was adopted for the coastguard (see Figure 126) which may be visible on cap badges in photographs.

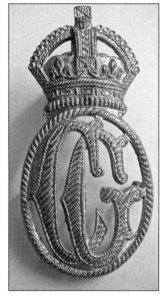

126. The CG emblem of the coastguard may appear on coastguard caps or badges.

Example Records for Coastguard Ancestors
TNA holds all surviving records about coastguard personnel. Consult their online research guide to find out more at www.national archives.gov.uk. The Coastguard Establishment Books (ADM 175) contain career records, and can be downloaded from TNA's website, but you need to know where your ancestor was based. There are also separate records available for pensions, and the activities of coastguard stations. Before 1923, *The Navy List* identifies postings for some coastguard officers.

Passengers and Members of the Public
A heaving deck was not the best place to take a photograph in the early days of the camera when long exposure times were mandatory. For many decades cameras were also a bulky, expensive and

comparatively fragile piece of equipment. Hence photographs of passengers on board a real ship are not common before 1900. Victorian photographers tried to compensate by creating ship-like backdrops in their studios for sitters who wanted a nautically themed photograph.

Despite the limitations, some early photographs taken at sea do survive but as with all old photographs it is not always easy to identify the date and the location – in this case the name of the ship. It is frequently not possible to identify a ship, but when studying the image with a lens pay particular attention to lifebelts and lifeboats as these should name both the ship and the vessel's home port. In the case of lifeboats this information is usually painted across the stern but also sometimes on the bows as well.

An example is shown in Figure 127. Here the photographer has captured a group of passengers at sea on board a steamship – you can see two funnels – but it is an early photograph because the vessel is rigged for sails as well. In the distance to the right, the stern of a lifeboat is visible and using a lens the name of the ship can be seen: 'SS *Alaska*, London'.

The *Alaska* was a famous British ship launched in 1881 that won the Blue Riband for the fastest crossing of the Atlantic and it became the first commercial vessel to make the crossing to New York in less than a week. However, *Alaska* was not very economical to run and ceased operating in 1894, so this photo must date from the period 1881–94.

However, there may be other clues to help identify a ship: a company flag fluttering in the background or the uniform of an officer or crewman may reveal the shipping line (see Chapter 2). A good tip is to study the image scrupulously with a lens as you may find an unexpected clue: a notice pinned up in the background identifying the ship, for example, or a name stamped on a fire bucket.

Figure 128 is an example of a photograph with no immediately obvious clues to the ship's name. However, using a magnifying glass it is possible to identify it. While at sea, the two women seated on the far right have both bought or borrowed crewmen's cap tallies

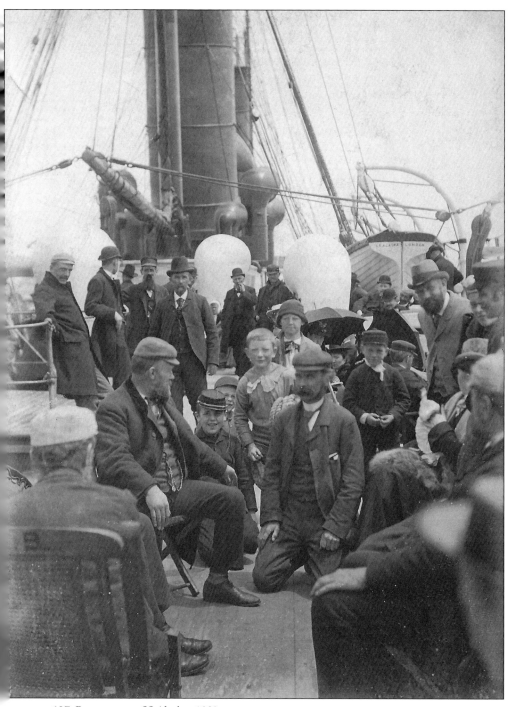

127. Passengers on SS Alaska, *1880s.*

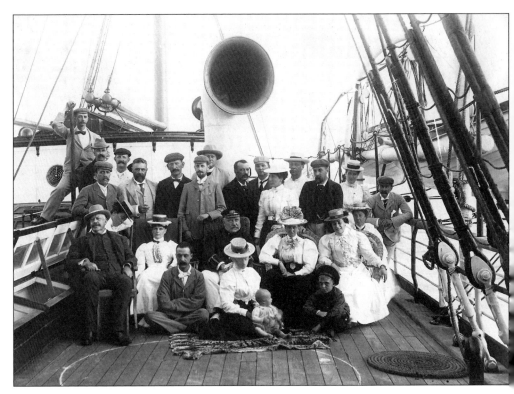

128. Passengers on SS Moor, *c.1895.*

bearing the ship's name and tied them around their boaters. The name of the ship can just be read: SS *Moor*. This ship was launched in 1881 and sailed regularly to South Africa, but changed its name in 1901 thus providing bookend dates for this image.

The era can often be estimated more precisely by noting the type of photograph, its style and design, and the fashions worn by the people photographed. For advice on all these aspects, a recommended book is *Tracing Your Ancestors Through Family Photographs* by Jayne Shrimpton (Pen & Sword, 2014). Fashion, especially in female passengers' dress, can offer vital clues in dating a photograph. For example, the 'leg o'mutton' sleeves worn by the ladies in Figure 128 puts this image firmly in the mid-1890s.

Passengers at sea are almost invariably photographed on bright, sunny days and so their clothing is often appropriate to this weather – looser and more informal. The degree of informality considered publicly acceptable varied considerably with the era. After 1900, society gradually became more tolerant of apparel that allowed more

of the human body to be exposed such as skirts that were not full length, bathing suits, short trousers and open-necked shirts. The clothing worn is also very much dependent on the passengers' social class, of course.

Figures 127 and 128 show every passenger covered up from head to toe – there are no bare arms, open necklines or bare legs and almost everyone is wearing a hat. The men wear three-piece suits with short lapels, watch chains, bowler hats and the majority have facial hair. Women wear white ornate bodices with full-length skirts and broad-brimmed hats. Contrast these images with Figures 129, 130 and 131 showing passengers from later eras.

Figure 129 was taken in 1925 and compared with Victorian times we see shorter hemlines, rounded 'bateau' necklines and cloche-style hats for women. The men have pointed but modern-style shirt collars with ties and longer jacket lapels; they are all clean-shaven. Figure 130 dates to 1937 and is a page from a passenger's photo

129. Passengers, 1925.

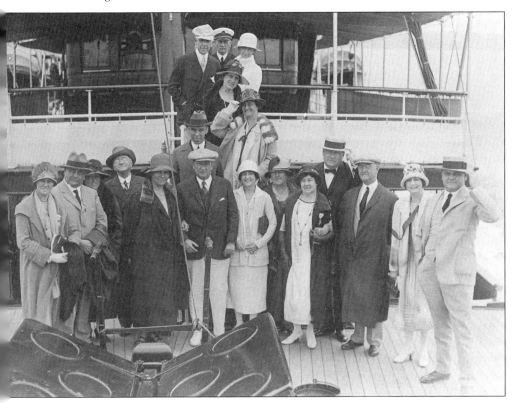

130. *Passengers, 1937.*

131. *Passengers, 1950.*

album showing women in short-sleeve or sleeveless dresses, and a swimsuit makes an appearance. Men are not wearing ties and have trouser 'turn-ups'. Headwear is only occasionally seen, and one passenger sports sunglasses. Finally, Figure 131 is a photo from 1950 and illustrates the diversity of highly patterned dress material, very broad-brimmed hats and shoe designs that gradually became available to women after the Second World War.

Photographs of passengers also reveal some of the entertainments that they commonly indulged in to while away the time at sea. This could include everything from a tug of war, to boxing, pillow fights, deck quoits, races, dances, cricket, fancy dress parties, tennis, swimming and, of course, relaxing in the sunshine.

Example Records for Passenger Ancestors
From 1878, people on ships can be traced via passenger lists on www.findmypast.co.uk and www.ancestry.co.uk. There are frequently similar lists held at foreign ports of disembarkation, as well as immigration records, so archives in other countries may assist you. In the past, first and second class passengers were often named in foreign newspapers when a ship visited a local port, even if they did not disembark. Passengers involved in a major shipwreck are commonly identified in newspapers too, but in addition there were official registers of passengers who died at sea. For example, series BT 158 to BT 160 at TNA covers the period 1854–91 and is on www.bmdregisters.co.uk and www.thegenealogist.co.uk, whereas BT 334 has deaths from 1891–1972 and can be searched at www.findmypast.co.uk.

Civilians in Seamen's Costumes
It has been quite common in the past for people with no connection to the sea to dress up in nautical garb. Sometimes Victorian photographers, especially at coastal resorts, offered clothes in which an individual might dress for fun. Sailors' costumes are not uncommon in this regard. So the cherished photo of great-grandfather from his navy days may occasionally turn out to be nothing more than one day's fun at the seaside. Another frequently

132. Family group with a young boy in a sailor's outfit, 1914.

encountered feature is the use of nautical backdrops or props by professional photographers – these do not always indicate that the sitter had a seagoing career. The customer may simply have liked the look of them.

Women would also dress in maritime clothing. Sometimes this was part of a prevailing fashion. Photos of women in seafaring clothes related to a professional maritime role are very rare indeed before the First World War. Even when such roles are caught on camera the women's clothing is usually distinctly un-nautical (e.g. Figures 7 and 32). An amusing situation, which is not uncommon, is an amateur photo of a wife or girlfriend wearing her male partner's uniform.

Children are by far the most frequently photographed non-seafarers depicted in nautical clothing. Thousands and thousands of boys in particular, but also girls, were dressed as sailors in the late nineteenth and early twentieth centuries as this was a very popular fashion. Photos of this kind usually date from the 1880s to the 1920s, but should not be taken as an indication that a family had a maritime connection. Figure 132 shows a young boy in a sailor outfit in 1914.

Animals
Finally, many vessels had pets on board – the ship's cat, a parrot to entertain the passengers, the captain's dog and so forth. It is surprising how often these much-loved animals have been caught on camera, especially in group photographs (e.g. Figures 4, 37, 43, 58, 79, 108).

BIBLIOGRAPHY

There are a number of books that focus on photographs of seafarers and life at sea, and on uniforms. Unfortunately, many of them are out of print but local libraries serving communities with a maritime heritage often have copies, as do specialist maritime archives.

Admiralty. *The Navy List*, various editions 1860–1950.

Bailey, Chris Howard and Thomas, Lesley. *The WRNS in Camera: The Work of the Women's Royal Naval Service in the Second War*, Sutton Publishing Ltd, 2000.

Brayley, Martin J. *Royal Navy Uniforms 1930–1945*, Crowood Press Ltd, 2014.

Coleman, E.C. *Rank and Rate: Royal Naval Officers' Insignia Since 1856*, Crowood Press Ltd, 2009.

Coleman, E.C. *Rank and Rate: Insignia of Royal Naval Ratings, WRNS, Royal Marines, QARNNS and Auxiliaries*, Crowood Press Ltd, 2012.

Elliott, Colin. *Sailing Fishermen in Old Photographs*, Tops'l Books, 1978.

Elliott, Colin. *Steam Fishermen in Old Photographs*, Tops'l Books, 1979.

Fabb, John and McGowan, A.C. *The Victorian and Edwardian Navy from Old Photographs*, B.T. Batsford, 1976.

Graves, John. *Waterline: Images from the Golden Age of Cruising*, National Maritime Museum, 2005.

Greenhill, Basil. *A Quayside Camera 1845–1917*, David & Charles, 1975.

Greenhill, Basil. *Seafaring Under Sail: The Life of the Merchant Seaman*, Patrick Stephens, 1981.

Greenhill, Basil and Giffard, Ann. *The Merchant Sailing Ship – A Photographic History*, David & Charles, 1970.

Greenhill, Basil and Giffard, Ann. *Victorian and Edwardian Sailing Ships from Old Photographs*, B.T. Batsford Ltd, 1976.

Greenhill, Basil and Giffard, Ann. *Victorian and Edwardian Merchant*

Steamships from Old Photographs, B.T. Batsford Ltd, 1979.

Hayward, Roger. *The Fleet Air Arm in Camera 1912–1996*, Sutton Publishing Ltd, 1996.

Jarrett, Dudley. *British Naval Dress*, J.M. Dent & Sons, 1960.

Macgregor, David R. *Square Rigged Sailing Ships*, Argus Books, 1977.

May, William E., Carman, W.Y. and Tanner, John. *Badges and Insignia of the British Armed Services*, A. & C. Black Publishers Ltd, 1974.

Rawlinson, John. *Personal Distinctions – 350 Years of Royal Marines Uniforms and Insignia*, Royal Marines Historical Society special publication no. 41, 2014.

Shrimpton, Jayne. *Tracing Your Ancestors Through Family Photographs*, Pen & Sword, 2014.

Sutherland, Jon and Canwel, Diane. *Fishing Industry: Images of the Past*, Remember When, 2010.

Trotter, Wilfrid Pym. *The Royal Navy in Old Photographs*, J.M. Dent & Sons, 1976.

Wake-Walker, Edward. *Lost Photographs of the RNLI*, Sutton Publishing Ltd, 2004.

INDEX